STREET
THROUGH TIME
Muriel V. Mudie &
Neil Clarke (Modern Views)

STREET
THE STREET SOCIETY
www.streetsociety.org

AMBERLEY PUBLISHING

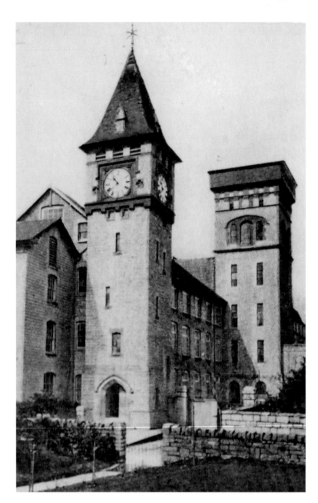

Most dominant of central Street's features is the façade of Clarks' factory. Though many buildings grew up beside it and, more recently, Clarks' Village right behind it, this is the architectural face that changes the least. The attractive tower is based on one at Thun in Switzerland, and in the alcove at its foot was installed the war memorial for past employees.

First published 2013

Amberley Publishing
The Hill, Stroud
Gloucestershire, GL5 4EP

www.amberley-books.com

Copyright © Muriel V. Mudie, 2013

The right of Muriel V. Mudie to be identified as the Author of this work has been asserted in accordance with the Copyrights, Designs and Patents Act 1988.

ISBN 978 1 4456 1679 7 (PRINT)
ISBN 978 1 4456 1694 0 (EBOOK)

British Library Cataloguing in Publication Data.
A catalogue record for this book is available from the British Library.

Typeset in 9.5pt on 12pt Celeste.
Typesetting by Amberley Publishing.
Printed in the UK.

Introduction

Central Somerset is a land of sharp contrasts, where the towering Mendips plunge down towards almost dead-flat, sea-level meadows that were once the bed of an inland lagoon; and where mankind's ancestors built huts on stilts at the water's edge, and hollowed out whole tree trunks for boats, as well as making exquisite jewellery and pottery.

Historically, Street follows the same contradictory lines. Is it really technically still a village, when it has facilities many big towns might covet? To name just a few: a full-scale High Street of what one might call proper (i.e. traditional) shops, and also a modern shopping village that brings in tourists year round; two public swimming pools, one indoor and one outside; several supermarkets (but two of them are seen across fields of cattle); a present-day logo that pictures a creature thousands of years old, found in a local quarry; not one but two well-equipped theatres, one of them forming part of one of England's best-regarded schools; a few remaining shops old enough to keep Street's very localised blue lias stone floors, compared with an internationally famed firm whose products attract buyers from as far away as China.

'Street? Oh yes, Clarks,' is a common response to the holiday question: 'Where do you come from?' And yet, there is also a constancy that has become lost in the fast-developing city suburbs. Return to an urban area after a ten-year gap, and the number of changes can be a real visual shock. In Street, businesses may have changed hands over and over again, but look up above these windows to the upper floors, and most of their general outlines are recognisable, as some of the pictures in *Street Through Time* can confirm.

Wrapped like a blanket around the central area, the green, traditional Somerset countryside embraces it on all sides, keeping alive scenes that our great-grandfathers knew. Cider – the real thing – is bottled only yards from the author's home, and meadows of spring lambs line the main Yeovil road that leads to panoramas that have changed little

since the Battle of Sedgemoor was fought on the flat Levels below. To the north the River Brue still usually overflows in winter, where legend says that the great sword Excalibur was hurled into the ancient lagoon and taken by a mystic hand.

It is all these contrasting components that make us Streetonians with seven or eight generations' pedigree continue to feel at home.

Logically, we follow in pictures a straight geographical line from West End through the main street as far as the River Brue. Then, more pictures go into many of the roads leading off it.

Whether you are old enough to say 'I remember that', or young enough to say 'I never knew that', these ninety pairs of then-and-now scenes will be for you.

Muriel V. Mudie

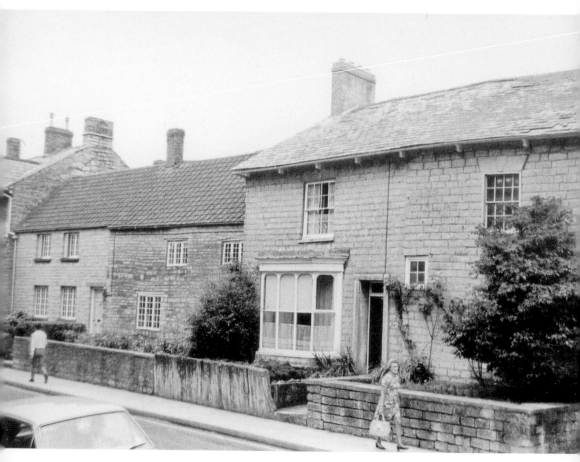

Cottages on High Street, *c.* 1970.

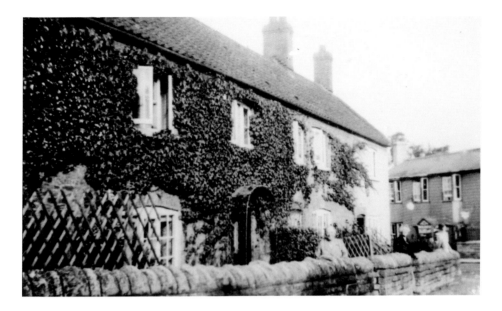

West End, *c.* 1942

Though the old name Teetotal Row still exists for a small byway, this entire group of cottages was also known as Teetotal Row. No trace of them now remains. A wartime snapshotter has lined up all the neighbours, surnamed from left to right, Clements, Pursey and Searle. The end cottage was enlarged by a one-room annexe and had a huge kitchen with stone walls that were cleaned with chalky water. In a tiny backyard was a standpipe which froze in winter; the solution was boiling water poured over the tap, and it never burst. Nor did the outdoor privy, worked by buckets of water, with the *Bristol Evening Post* cut into squares and hung from a nail. Street then still relied on gaslight. Changing gas mantles was not as easy as an electric bulb. Once screwed in, it had to be lit with a match and burned off with a strong, gassy smell before settling. Right opposite, in the middle of the crossroads with Stone Hill, stood a heavy stone horse trough, still occasionally used if a few cattle were driven past, or a horse used to eke out rationed petrol. It was installed by the philanthropic Miss Ansell of Holmwood in 1893, along with the more ornate cherub trough at The Cross.

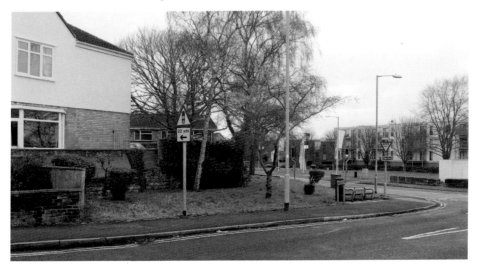

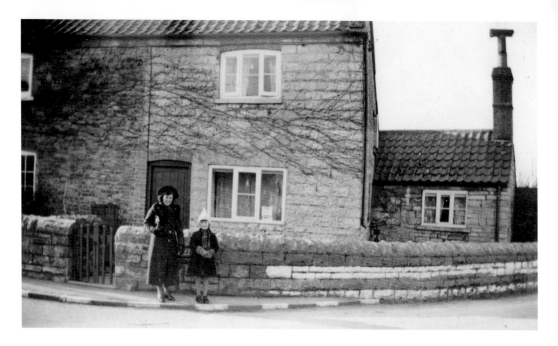

No. 4 West End, 1940s

Nothing remains of this scene, only a corner patch of grass with the same curve in the road to identify it. A public seat marks the old front gate. The last of a group of cottages known as Teetotal Row, No. 4 had a distinctive little one-room annexe with a strange topknot supposed to prevent smoke drifting back into the room. Gas lighting was still almost universal locally. Rows of stones in the outer wall have been picked out in white paint to aid walkers with torches during the Second World War blackout. Similarly, lampposts and trees were marked, as people went out after dark for social events. The lady had trained with a court dressmaker. Her coat was skilfully cut down from a second-hand one, and from the remaining fabric she also made a smart matching hat.

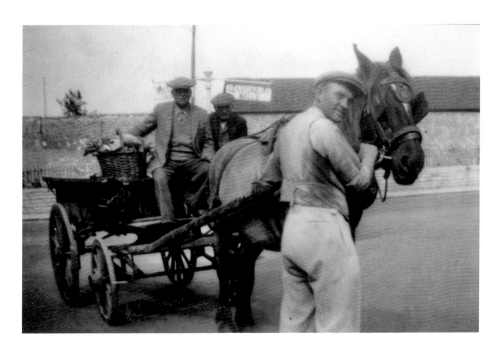

Corner of West End and Stone Hill, 1923

Only a public seat and a patch of grass near the police station mark where this snapshot was taken in 1923. The basket of fruit and vegetables was about to be dropped off at No. 4 West End. The seat is almost exactly where the front gate was, and the pavement still follows the same outline of the corner. Even on a working day like this, men liked to dress 'respectably'. The writer's grandfather, known in 'Zummerzet' speech as 'Gramph', wears a collar, tie and jacket, and they all wear caps. The other two are his brother, Pat Searle, and Pat's son Will. Only one month ago, in December 2012, the whole location was identifiable by sitting on the public seat and looking straight across at the old walls. Now they are gone, revealing more of the huge new housing estate of Houndwood.

West End, 2012

Sometimes history moves faster than expected. Less than a year before writing these words, the massive old wall facing the corner of West End looked its familiar self. Later, a glorious wisteria smothered it as usual, and a small magnolia flowered. But behind it a new estate of houses and flats grew ever larger. Finally, in the New Year of 2012/13, it was gone.

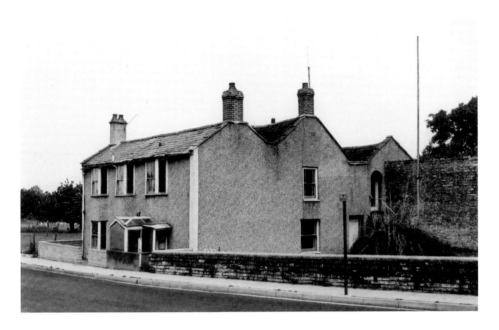

Tazwell's (or Taswell's) Off-Licence, 1972

No trace remains of this off-licence at West End, where there is now just grass in front of a block of flats. Not a shop, it fitted into the front room of a house, with the porch window used for display of bottles. The view is from No. 4 West End, right opposite, whose inhabitants never darkened Tazwell's door, being good Streetonian teetotallers. Their forebears, however, had no such misgivings, patronising every pub from the Street Inn through to the Ring of Bells at Ashcott, reached by pony and trap. From them we even have a record of Tazwell's sales in 1896: 'Beer from Tazwell's (Oakhill Brewery): Ale (light ale) 3d per quart; Beer (strong ale) 6d per quart; Porter (stout) 6d per quart.' 6d equalled 2½p and 3d was 1¼p. Other inns they patronised included the Street Inn for its Somerton Ale, the Globe for Oakhill brew, and the Royal Oak for Charlton beer.

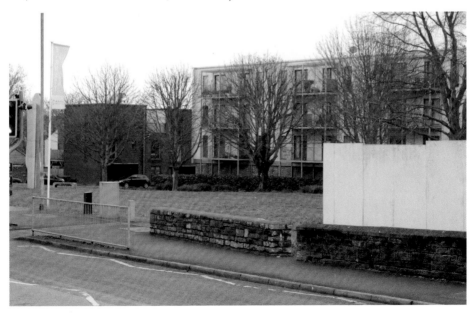

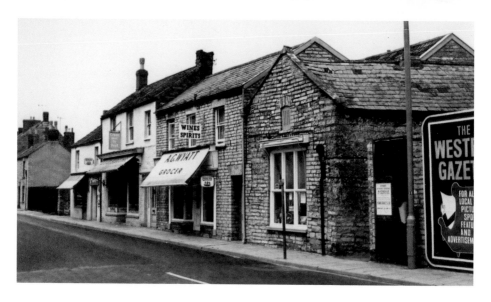

Opposite Goswell Road, Early 1970s

Six years after the most recent 'Great Fire of Street', two or three of these buildings are still boarded up while controversy continues over rebuilding them. As in so many urban scenes, shop blinds like these have generally gone, with the advent of air conditioning. In a heatwave blinds were a boon to customers, to stand at the shop window in the shade before moving to the next one in the line. 'Cream Sent By Post' reads one sign for any visitors who fancy Somerset dairy gifts. Traders of the past include the well-remembered Slocombe's Dairy and its ice creams, and another shop with these very low windowsills at child height. Tales continue of a Board School teacher who invented the Non Nail Nibbler's Club (NNN). Each one in her class had a card outline of a hand, showing which nails had been chewed. The winners' good cards were laid along the window bottom, hopefully to shame the rest, as the good child's name was on each one.

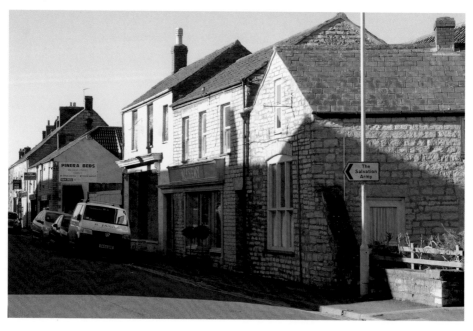

Cooper's Fish Shop

Hearsay states, whether true or not, that when Cooper's fish shop had a fire, the High Street smelled like fish and chips. By then it had recovered from its wartime limitations, when stock was usually so low that mothers had little choice but, for some reason, shrimps; and the offcuts known as cat pieces, sold cheaply, boiled, and with a disgusting smell for the family moggy, before canned foods became universal. Next door, on the same group of shops beside what is now the URC (United Reformed Church), many people also recall 'Old Mr Stapleton's', a crowded little stationery shop run by a man who, to a seven-year-old, seemed like Methusela's grandfather. He was popular for helping children spend their pocket money (then around sixpence or 2½p a week) on such trivia as sheets of tissue paper – a different colour each week – or 'undeliable' (indelible) pencils that were waterproof. They were carried in cotton bags for break-time games in the Board School playground.

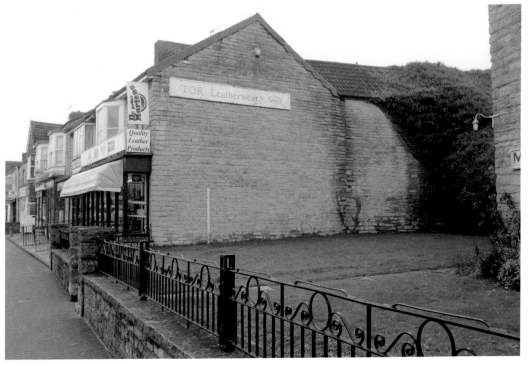

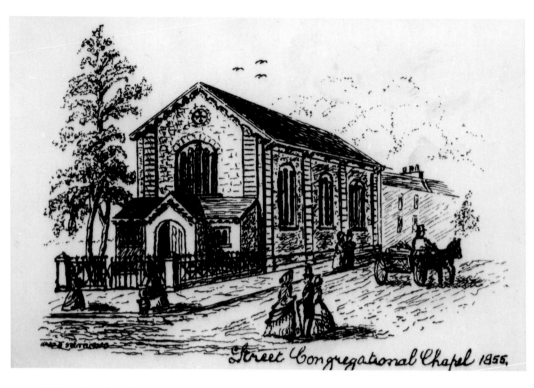

Street Congregational Chapel 1855.

URC and Orchard Road, 1855

This reproduction of a Victorian view shows how the URC's general appearance has remained constant, though the cottages lower down the road were replaced by blocks of flats. Each year a large flower festival fills the main church, running for several days, during which the Rest-In-The-Lord Cartwright organ is usually played at various times. The change of title from Congregational to United Reformed Church was a twentieth-century move.

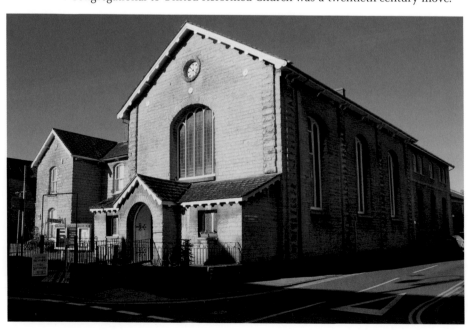

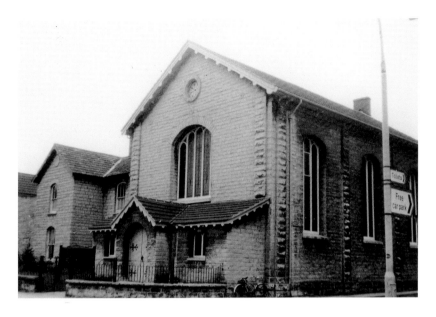

URC, Late 1960s

In tune with virtually everything else in Street, the chapels and churches grew rapidly in attendance as more and more families came here for work, attracted by tales of especially good conditions and new factory housing. Through the 1880s, with the Revd William Stacey as minister, numbers rocketed, and continued to grow after Revd William Boulter took over. By the time Edward VII had settled into kingship, Street Congregational Church boasted about 200 members – and that was just the adults. There were also around 300 Sunday school children. Like many other non-conformist churches, the Congregationalists were known as 'a sociable lot', filling almost every weeknight with meetings and activities. As the United Reformed Church (flippantly but affectionately dubbed the 'Erk') it continues to host bazaars, concerts, and all manner of meetings.

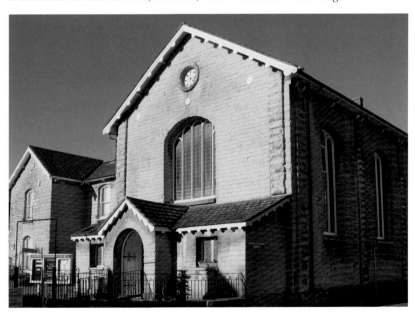

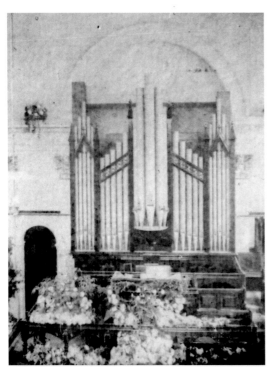

Organ at Street URC, 1907–08
Old Puritan names lingered among Nonconformist families well into the nineteenth century. From school history lessons many of us at Elmhurst giggled over Praise-God Barebones. Similarly, a Mr and Mrs Cartwright called their boy Rest-In-The-Lord. Reduced to a less cumbersome Rest Cartwright, he became an organ builder who, in Somerset, made the instruments at St John's, Glastonbury, and at what is now the URC in Street, where it dominates the church. In 2007 the organ's centenary was celebrated with a concert based on the original opening programme. Restoration made it once more a superb organ to play, remaining little changed from 1907. The writer's grandparents and great-grandparents heard it at their children's baptisms, and those children's descendants regularly hear it today. This picture is believed to date from the then new organ's earliest days.

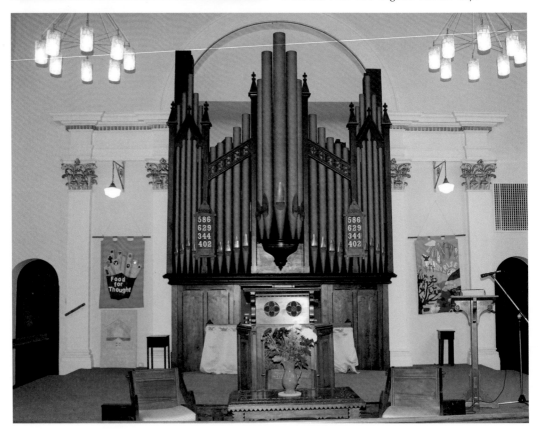

May Day Outside the Chapel, *c.* 1914

At the Congregational chapel (now the URC) May Day has been a major calendar festival since Victorian times. Then, the church used Crispin Hall, bigger than its own premises, for a two-day May event. One year, around the 1930s, almost the entire hall was filled by a massive *Mayflower* ship model, big enough to take a crew of about eight men. Descendants of the children pictured are known to still live nearby. The Second World War forced a change of location which still holds true today, when Crispin Hall was wanted for a British Restaurant (or Civic Restaurant) where very basic meals like sausage and mash could be bought to save food rationing coupons. These simple cafés opened all over Britain; a few even lasted into the 1950s, as in central Bristol. To make way for this, May Day was moved to the large hall behind the then Congregational church. The maypole was squeezed inside by chopping a length off the top. This hall was well used in wartime, for entertainment such as the Vari-Lights variety group.

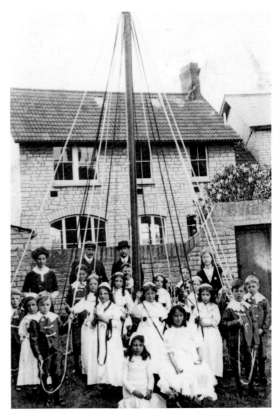

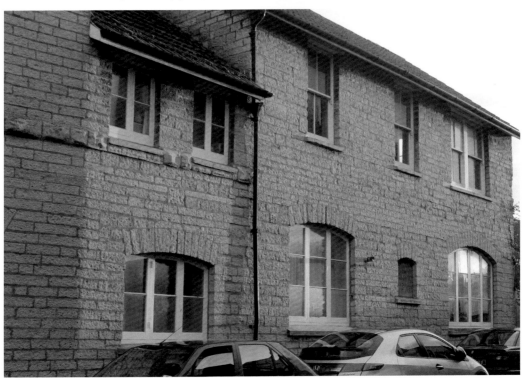

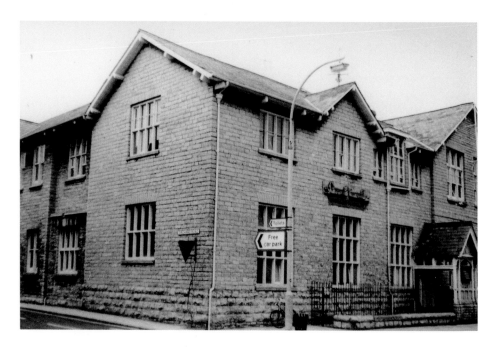

Board School, 1970s

The words 'Board School' still cling to the façade, but in its last days before being turned into a shop. The front entrance is clear to see, with its stolid little porch and railings. The latter channelled children onto the pavement instead of straight into the road, but was eventually removed. Behind the school was a large playground where boys and girls could mingle at break-time. Many people will remember playing marbles there, fiercely hoping to capture a blood-alley – white with streaks of red. Mothers sometimes made special cotton bags for their children's marbles, which were carried everywhere like collections of loot. 'Does thee carry thicky brains in thicky bag?' yelled the school bully from his bicycle. The large main hall, now filled with furniture displays, was sometimes used for jumble sales and fairs at weekends.

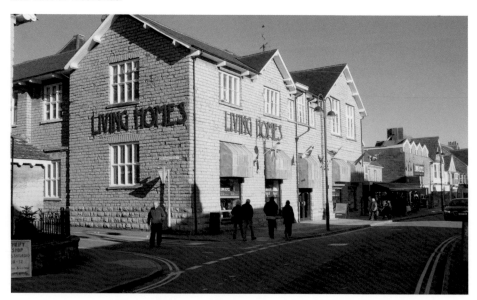

Porch at the Board School, 1974

Though the massive Board School survives
as the Living Homes store, where many
classroom features are kept visible, this front
porch is gone, having once jutted right out
across the pavement. This was deliberate;
excited children at home-time could not run
straight out and into the road. Instead they
were deflected to the side, safely enclosed by
railings, down an incline. Initially, in 1831, a
National School was founded by Revd Lord
John Thynne, and a British School by the
Quakers, based on the British & Foreign Bible
Society's teaching, whereas Thynne's children
were immersed in the Catechism. The Quaker
Clarks, always against war, had supplied
sheepskin jackets to frozen Crimea soldiers as
a humane gesture, and decided to donate any
profit from them into education, such as new
school buildings. Under the 1874 Education
Act, this became a Board School, by which
name most older residents still refer to it.
One former teacher tells how, when going
upstairs to buy something, she automatically
turns toward the old staffroom.

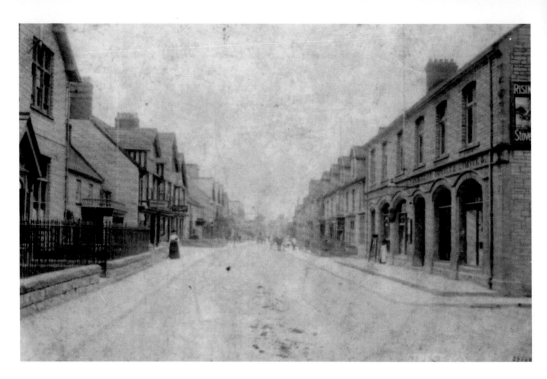

Corner of High Street and Vestry Road, _c._ 1905
From the start of the picture postcard age, the prominent Co-op on the corner has reflected changes in shopping for over a century. This early record, before the front clock was added, shows the dignified arched frontage which was to undergo so many changes. Today it is split up into smaller shops including a bookie, but the overall building remains identifiable.

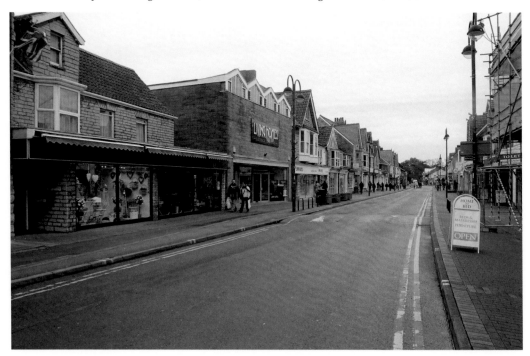

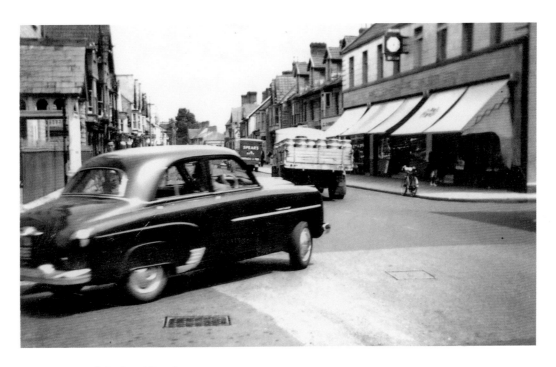

Corner of Orchard Road, 1950s

Oh how this snapshotter cursed when a car swung right across the view! The film was almost binned, but now it is a historic record for its background, and even for the car. A van named Spears is parked in the main road for delivering to a shop, while a truckload of milk churns squeezes past, confirming that milk still came in churns and bottles, and nothing plastic. But changes are starting to occur: the Co-op (*right*) has become an early supermarket.

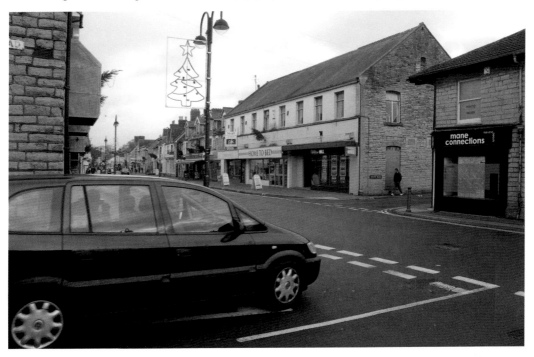

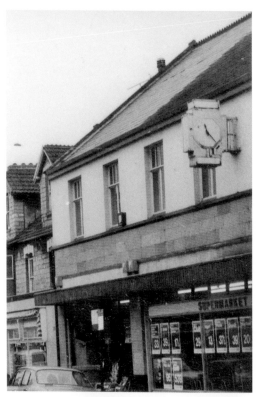

Co-op Clock, 1960s

Through most of the twentieth century, High Street views have included the Co-op's public clock. Two useful things for daily living were here: the time and the Dividend. A precursor to the loyalty card, the 'Divi' paid about sixpence (2½p) in the pound and could be redeemed either in cash or in goods from the shop. Mothers with several children relied on this regular bonus to help with school or household bills. When the Co-op returned to Street, but on West End, many a customer asked if she could revive her old Divi number. Ours was 38617.

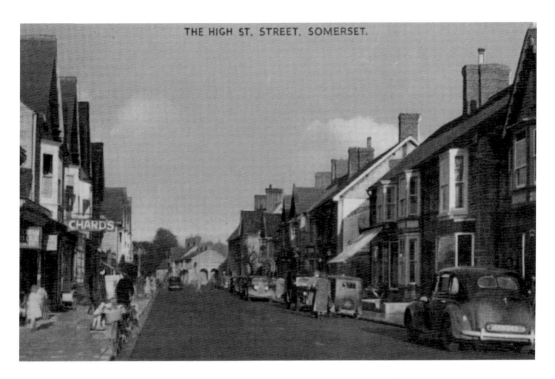

High Street, Probably 1950s

Here is a spot-the-difference picture-puzzle, between roughly the 1950s and 2013. Traffic driving towards Glastonbury totals just one car, but others are parked outside the shops. One is about to be unlocked by a leisurely couple with shopping bags. More distantly, shops beside Crispin Hall have not yet been turned into the Crispin Centre, and at the opposite kerb, bicycles have been parked right outside an old-fashioned ice cream parlour. The form of human life known as a traffic warden had probably not even been born.

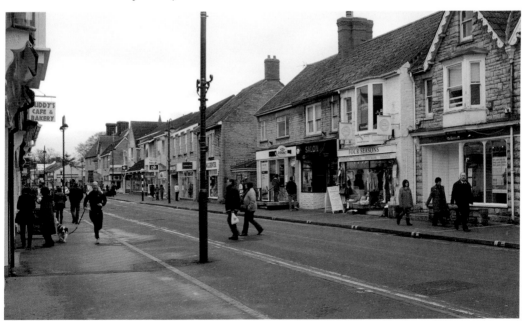

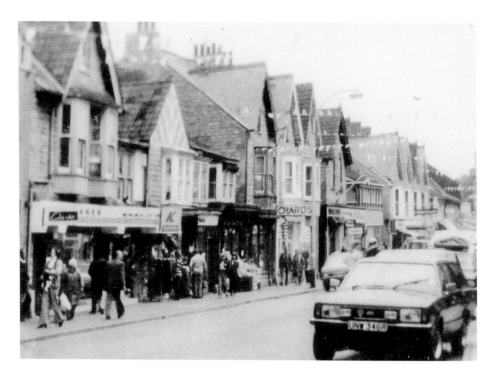

Royal Wedding Week, 1981

Various celebrations have passed since the week when bunting spanned the road for the wedding of Prince Charles and Princess Diana in 1981. It is now only months since the Olympic flame was carried past these same businesses, whose names have often changed but whose general outlines above ground-floor level are mostly recognisable. Three principal names in this Mecca for shoe-buyers are prominent: Clarks, K, and Chards. As in so many shots taken at this period, the most obvious sign of change is the parked cars.

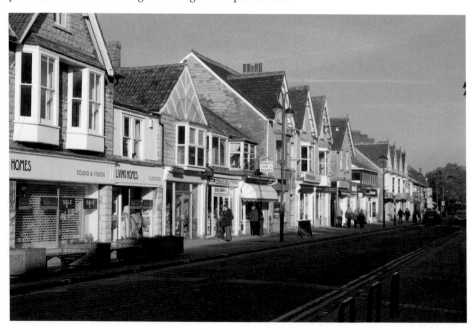

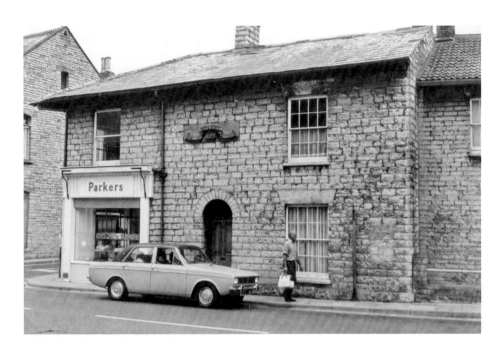

Corner of Vestry Road, 1970s

Left of the Old Vestry Room is the corner of Vestry Road, once known as Pound Lane. Many a country place has a Pound Lane to record a village pound where stray cattle were rounded up and held; such an inn exists at Coxley, with its pictorial sign. In 1881 a Vestry Room was built here, as proper local governance drew away from a discussion-and-beer evening towards formal guidance by committee. Vestry Road, as we know it, dates from after February 1863, when the 'Great Fire of Street' consumed virtually every house. A howling winter wind sealed every neighbour's doom, as wood and thatch quickly succumbed. Countrymen familiar with such scenes explain that thatch can virtually explode before sliding down off the roof to create on big bonfire. Not surprisingly, the replacement houses are of very solid stone.

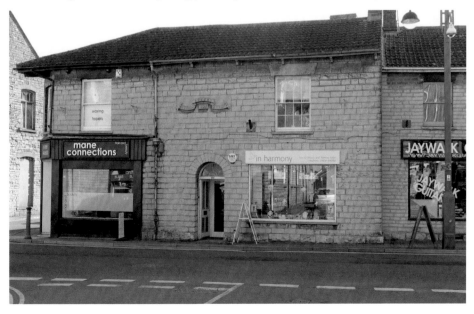

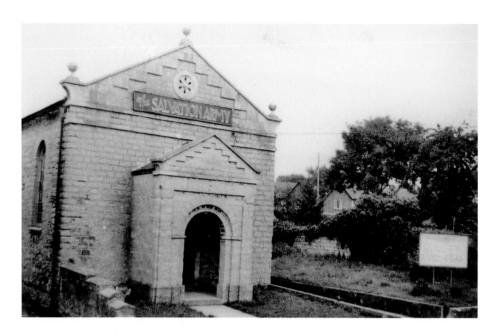

Salvation Army Hall, 1960s

In 1886 the Salvation Army opened its first hall, a tiny chapel that is seen from Tesco's car park, tucked behind the High Street. But by 1906 it was already too small for special events, and they did not come any bigger than a visit from William Booth, the Founder himself. During a gruelling tour from Scotland to Cornwall he swapped a car for a carriage at Millfield to drive down to Crispin Hall with Miss Alice Clark. At Millfield he had been offered a good lunch, but Booth, a vegetarian, preferred very simple food when so many people were starving. Aged seventy-eight, he was described as 'a tornado of fire', preaching his way from Highbridge to Street and Glastonbury, then on to Frome. Yet he made time to visit just one individual in a little cottage. Mr Carroll, a fervent Salvationist, had the General sitting by his own bed not long before he died. Soon the Salvation Army moved on into a bigger chapel in Goswell Road, whose successor sits on the same site.

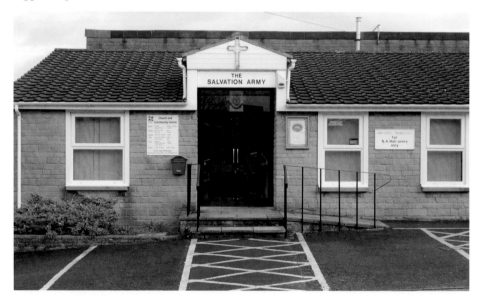

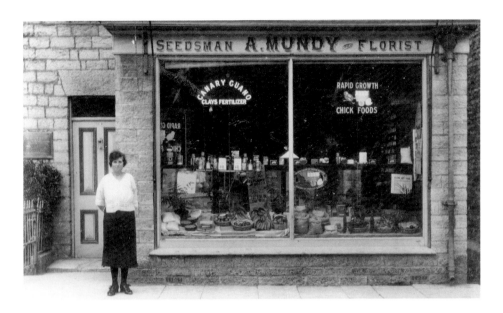

Mundy's Shop, *c.* 1920

Mundy's florist business is one of the oldest shops still keeping the same trade and name as around a century ago. Apart from moving premises from the middle of High Street to a building near the Board School, this old family enterprise keeps pace with modernity but without losing its past. An aunt of the current owner stands outside the earlier shop in the costume of the 1920s, where signs and window stickers proclaim Mundy's services: seedsmen, florists, suppliers of guano. Before commercially packaged fertilisers, guano (otherwise known as sea birds' poo) was a universal fertiliser both in agriculture and gardening. The Gibbs family built their vast mansion of Tytesfield from importing huge tonnages of guano from South America. The earlier Mundy's shop, currently the Edinburgh Woollen Mill, stands beside a byway into Clarks' Village, named after the family as Mundy (not Mundy's) Walk. It marks where a track led to the firm's own nursery and market garden, long ago buried first under two of Street's earlier supermarkets, and then under the commercial Village. Here were the firm's greenhouses and plots for raising plants. A long, long way removed from our present garden centres like Cadbury or Sanders, but doing the same service for a very localised area.

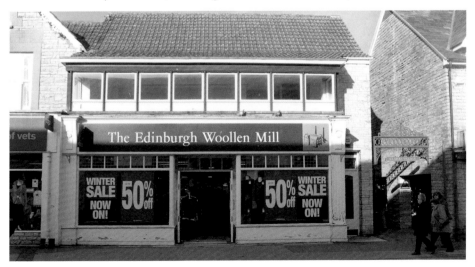

Middle of High Street, 1980s

Victorian houses just this side of Crispin Hall have not yet been sacrificed for the Crispin shopping centre, whose biggest occupant is Tesco. A few generations ago they would still have kept their private front gardens, which were eventually given up when the ground floor of each house first became a shop. Through the Crispin Centre and out towards the car park some of the modernity is relieved by a wonderful relief panorama of Somerset scenes created by Philippa Threlfall of Wells, with an explanatory diagram from the Street Society. In delicate detail are shown Wells Cathedral, Glastonbury Abbey, the Levels at Meare, the factory clock tower, and landmarks from as far off as Axbridge and Taunton.

Chard's and Puddy's, 1970s

A few really old businesses carry on trading among today's shops, such as Grinter's the pet shop (with its old Polden stone floors) and Puddy's the bakery. Even in today's mass-produced age, Puddy's still produce a jam and cream tart that seems unique to them. To munch one of those is to board a time machine back to childhood. There is no mistaking where Chard's shoe shop is; the projecting sign looks extra big from this angle.

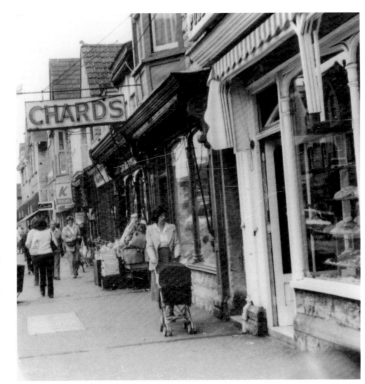

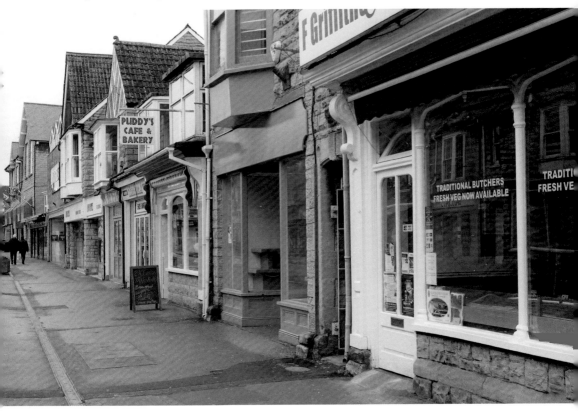

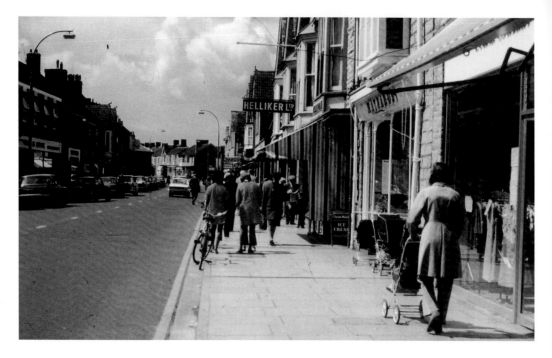

Helliker's Shop, Possibly 1980s

Helliker's large shop is fondly remembered by many people today, who spent their pocket money there or bought gifts over the counter. One did not need to look in the window to locate Helliker's; the name on its distinctive but simple sign, stretching out halfway across the pavement, was enough. Edward Charles Helliker, born in 1863, ran his printing business here and former shoppers' memories are naturally drawn to Helliker's for stationery and paper products. Nearer the camera is Maynards' Café. One yellow line keeps the right side free of traffic, but when the scene was filmed, it was still possible to park opposite. Around a dozen drivers have stopped outside various shops, seemingly free to linger.

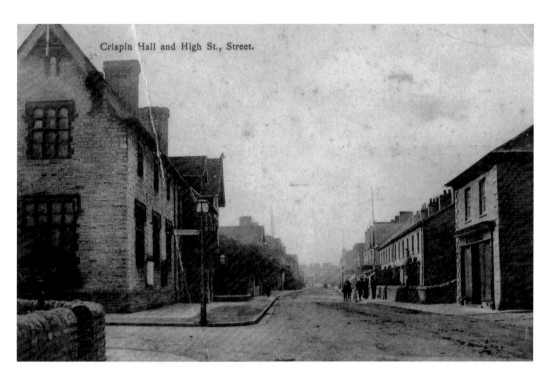

Crispin Hall and High St., Street.

Crispin Hall and High Street, *c.* 1915–20

Though businesses continually change, the buildings' upper storeys can remain remarkably constant. A few former cottages have sacrificed their little front gardens and stone walls to commerce, and their overhanging foliage, but overhead they survive. Of horse traffic though, there is plentiful evidence. When shopkeepers lived 'over the shop', those who kept gardens regularly took a bucket and spade out onto the High Street and helped themselves to manure.

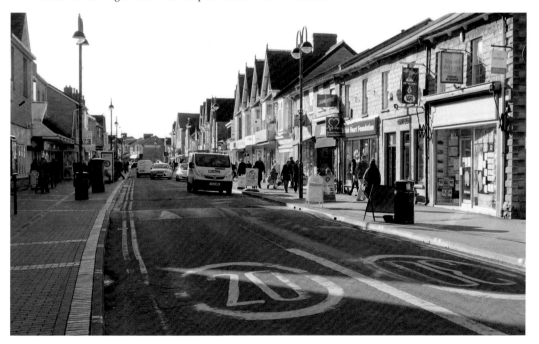

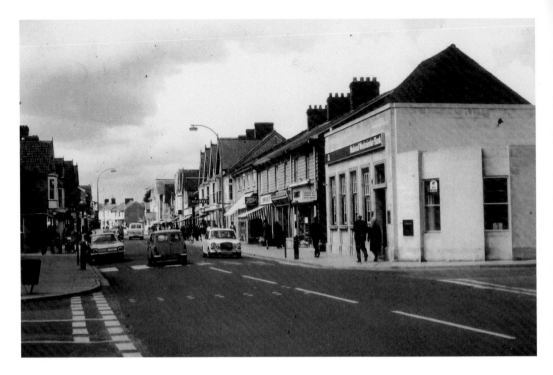

The Same Corner, 1980s

By now, the right-hand corner shop has metamorphosed into a bank, brought outwards to align with the adjoining cottages. They in turn have lost their tiny front gardens and stone walls, and become shops. But enough of their upper storeys survive to match the two scenes, even over half a century later.

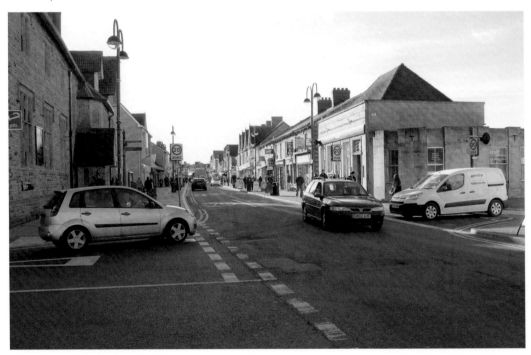

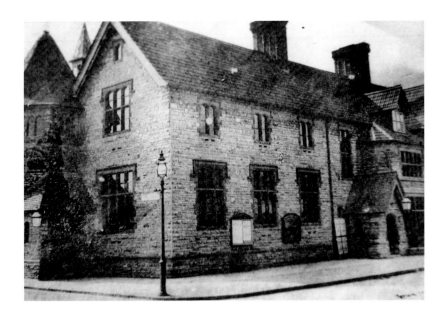

Crispin Hall, *c.* 1970

Crispin Hall, named after the patron saint of shoemakers (of course), opened in 1885 as a public hall with a library, museum, and all sorts of leisure and educational facilities for the workers. It was a social hub for generations, staging everything from flower shows to premieres of Rutland Boughton's operas. Since the opening of the Strode Theatre, Crispin Hall's intensive use has inevitably declined, but recent work has made it once more watertight and well-glazed. It still hosts a Thursday market, events such as dog training, and special sales. Much involved in creating this landmark on the High Street was the local building business of Bowring & Hawkins, headed by Henry Hawkins, who was also an auctioneer and surveyor. Henry Hawkins also built the now lost Butleigh Hospital.

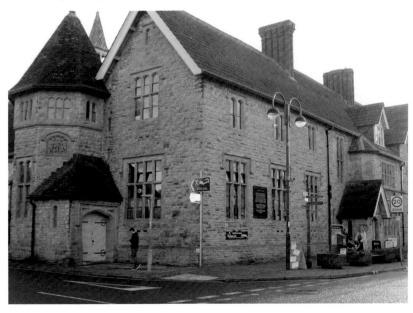

The Bear, *c.* 1970

Teetotalism, Quakers and Clarks: the three perpetually intertwine and give rise to various anecdotes. The story of the Clarks' new house, Netherleigh, remains a favourite for retelling: how that great promoter of abstinence, Cyrus, symbolically demonstrated renunciation of the 'Demon drink' as the walls took shape. Cyrus Clark took out his small number of bottles, broke them, and poured the liquors into the mortar that was holding Netherleigh together. Less often told is the similar incident that occurred right opposite, when the little old alehouse called the Bear was demolished and rebuilt in 1894. From the pub's own cellars, any remaining cider and ale was again mixed into the mortar. The new inn was intended as a coffee house, kept 'dry' so as to remove all temptation for men leaving the factory. Right through to 1977, the Bear continued without a licence for alcoholic drinks. To this day, in the twenty-first century, Street still has fewer pubs than most places of comparable size; and down at West End the name Teetotal Row still survives.

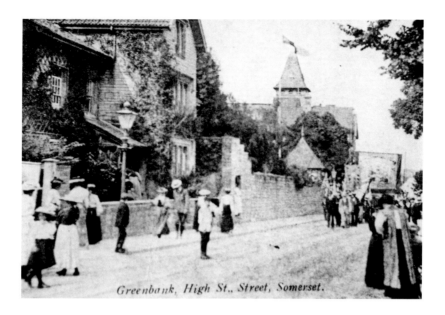

Greenbank, High St., Street, Somerset.

An Exciting Procession, 1904

When travel and entertainment were limited, any kind of public display brought out the crowds. Such was this day in 1904, important enough to be a local day off for workers. As this special procession approaches from near the Bear, huge banners can be seen, presumably Temperance Societies rather than trade unions; indeed, they are about to pass the Temperance Hall. In 1898 it was proposed to harness enough water from a site near Pilton to supply both Glastonbury and Street. In true inter-village spirit, Street said no, and decided to 'do its own thing'. In June 1904 there was an official opening when the supply was turned on. Street Brass & Reed Band led the way to Keens Sugg, where the pump was finally turned on to loud cheers. The climax was to have been a show of the water's power by the fire brigade near Crispin Hall. Unwilling to take chances, the brigade first had a quick rehearsal a few days earlier. However, this usage had dramatically reduced the water level, and on the big day, the expected drama proved to be but a trickle.

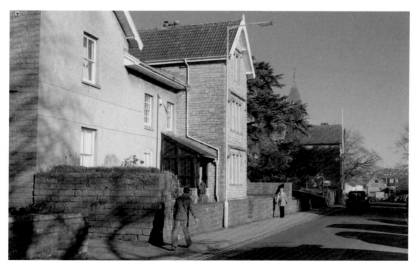

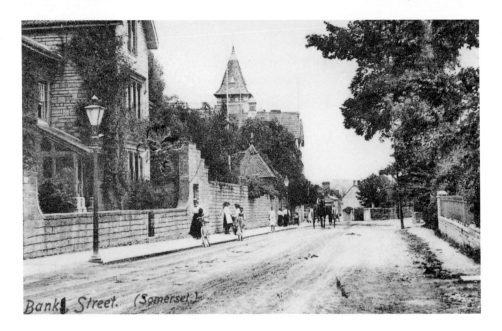

Bank Street. (Somerset.)

Green Bank, 1905

How a simple postcard found its way from here to Canada in 1906, and finally back to a house within walking distance of the same scene, would need a Poirot to explain. Just for once Higdon has erred in his caption, and E. Clark, when writing to Miss Lizzie Stewart in Ontario, has crossed out an 's' – it is Green Bank, not Banks. The house, Green Bank, faces gardens where eventually Greenbank Pool would be made. The sender is one of *the* Clarks, describing it as 'the house ... where my old Uncle lives' at ninety-four years old. She adds: 'Beyond the house is the Jubilee Clock Tower of the Boot and Shoe Factory; opposite the house is a garden which used to have a green bank in front, therefore the name.' By then getting around was much improving, with wide pavements and gas lamps; many a large town was only just getting around to such things in Edward VII's reign.

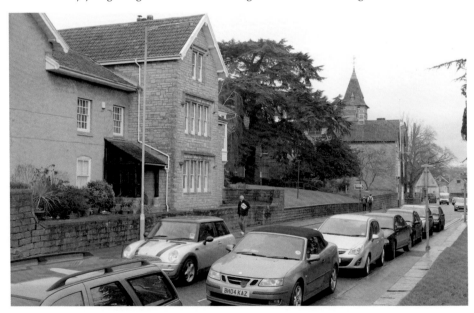

Temperance Hall, 1981

Racks of clothing outside a shop on the pavement are an unusual sight, compared with city streets or even seaside resorts like Minehead. Shop blinds of heavy canvas, pulled down with a long pole, are increasingly rare today. Eventually the blinds were replaced by a permanent roof starting higher up the building, above which is a single word on a stone plaque: 'Temperance'. This tall, sober block started life as the Temperance Hall; the second word 'Hall' is obscured by the newer frontage. It forms yet another link between workers and employers. Street offered so much to its employees: good housing, fair pay, good working conditions, education, leisure facilities... But the price was sobriety as preached by the Quakers. Water was so polluted as to cause cholera epidemics, less safe to drink than cheap booze. The Temperance Hall offered workers relaxation but without alcohol. Sadly, however, it did not really earn its keep, and was later rented to a grocer, Edwin Kennedy. A few doors along, an entrance to Clarks Village was cut between three shops without disturbing their upper gables. The bunting marks Diana and Charles' royal wedding.

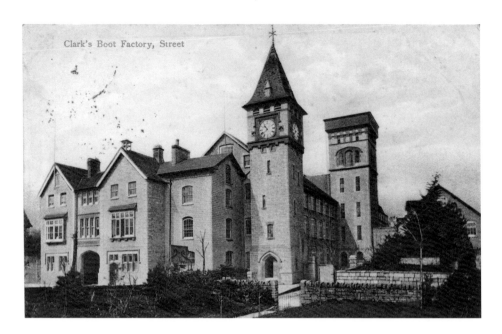

Clark's Boot Factory, Street

Clarks' Factory, 1910

Clarks' story, so intertwined with that of Street, is far too long to tell here. So we choose just two products to represent them all. Serving in 1940s Burma, Nathan Clark spotted a simple boot of suede and crêpe being worn by British troops, which originated in the Cairo bazaars. Perfect for such terrains, the pattern he cut from newspaper in his barracks did not impress at home, but proper sample pairs made in 1949 suggested otherwise. By his death, aged ninety-four, in 2011, the 'Desert Boot' had sold 12 million pairs. At the other climatic extreme was the 'Eskimo Boot' for much smaller feet. When the Sadlers Wells (now Royal) Ballet toured Canada and the US, the dancers – including Fonteyn and Shearer – were fitted with these stylish new boots. The gesture did the makers' export market no harm either.

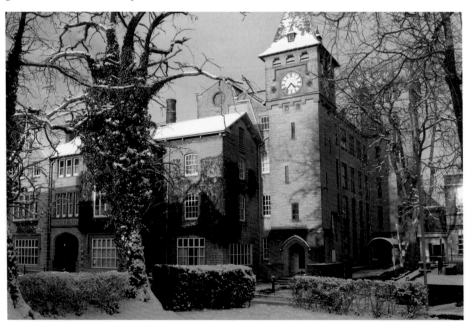

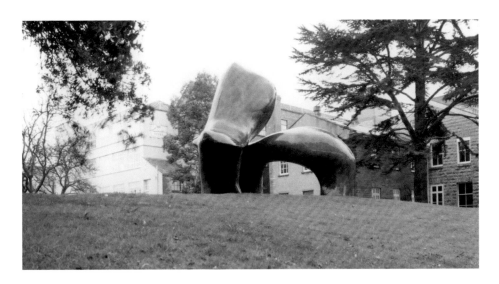

Sheep Piece, c. 1980

What do a famous company, an empty grassy embankment, a can of Pepsi, a sheep, a shoe, and a day's shopping have in common? The answer used to be right in the middle of Street, but is now across the Atlantic: a sculpture by Henry Moore. Visiting a London exhibition by Moore, Ralph Clark conceived the notion of combining love of art with Street's most famous product, and brought a Moore work here. The choice fell upon *Sheep Piece*, due to leave the Serpentine Gallery show anyway. It took two large lorries to transfer the 2-ton sculpture to the green garden outside the factory, and deposit it in its chosen place. Moore then wanted it moved, only to change his mind and have the cranes move it back again. The named cost was about £150,000 in late 1970s prices. Manufacturing fortunes, however, began to decline, and thoughts turned to putting the company name to a new venture in selling. £2 million later, *Sheep Piece* was again hoisted onto massive lorries, this time for a voyage to the town of Purchase in New York state. There, the Pepsi Cola HQ included a wonderful sculpture garden, where Henry Moore kept company with such names as Giacometti and Rodin. The sale of *Sheep Piece* helped create Clarks Village, where thousands of visitors a year can purchase everything from a shoe to a casserole dish.

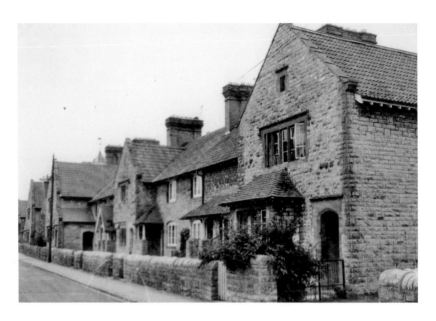

Wilfrid Road, Late 1960s

Open almost any book about the Arts and Crafts movement, and there is a fair chance that Wilfrid Road will appear. It is regarded as a classic of that style. When, in 2012, the Street Society in an annual Heritage Open Day staged a public viewing of the whole road, hundreds of visitors arrived. By arranging to close Wilfrid Road to traffic, it was possible to really appreciate the houses and gardens. Three residents even opened their houses on this one day. The three groups – Wilfrid, Cobden and Lawson Terraces – blend so well that few casual observers realise they have different architects. George John Skipper, whose Norwich base still seems unclear in relation to Somerset, accounts for a well-known tale of a cupola. Today most of us think it has great charm as a rooftop feature of Cobden Terrace; however, one of the Clark ladies, a Quaker opposed to ostentation, was so offended by its inclusion that Skipper was not engaged again.

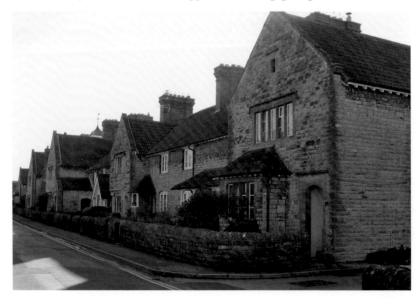

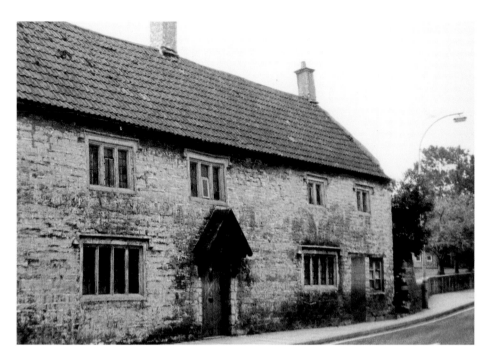

The Mullions, 1960s

Once a farmhouse, the Mullions is now familiar as a hotel. One room's huge stone fireplace is believed to have come from Glastonbury Abbey; very likely, as it became a giant quarry for locals wanting ready-cut building stone. Nearby stood the unusually named Sanduskey House and Terrace. Dick Godfrey, a builder, is credited with creating this and Shields Terrace. Early in the twentieth century his brother left for America and became a showboat musician, probably on the Mississippi, where the stern-wheelers still often carry a band. His home base was a place named Sanduskey.

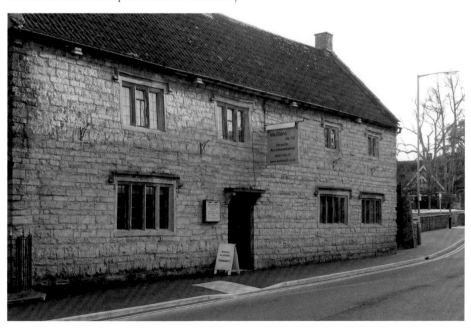

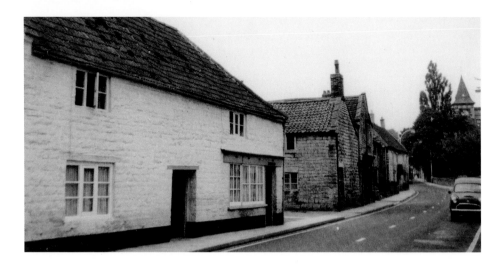

Vineyards and Reeds, *c.* 1970

Once known as Reeds (No. 19), this big cottage is said to have been divided inside between two families. There was also a dairy hereabouts. Behind this area was a smallholding or farm. The still-extant names of Gifford and Difford both occur in a handwritten memoir from the late nineteenth or early twentieth century, concerning Difford's stabling of the fire brigade horses; two were expected always to be at the ready, which in many alarms would move towards their engine quicker than the people who were supposed to man it. By the time Mr Gifford in Leigh Road had been alerted to start an alarm, and Gifford had pedal-cycled down to Difford to prepare the horses, and pedalled to various other addresses to round up the crew, at least forty minutes had been lost. Another old memory of the Diffords recalls early ice cream production, created by one Bessie Difford in her milk bar. Customers were served through a traditional stable door, the top half flung open but the lower half shut. Between them, the useful Diffords and Giffords could sell you an ice cream, deliver your milk from their cows, and put out your blaze if a log or turf fire got out of hand. The smaller cottage, No. 17, took the name of Vineyards.

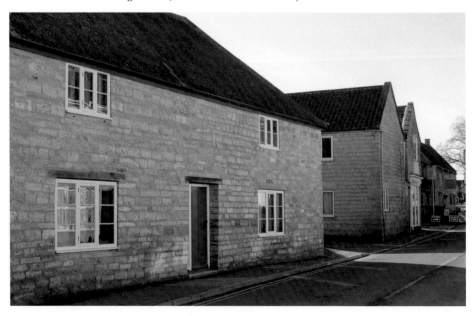

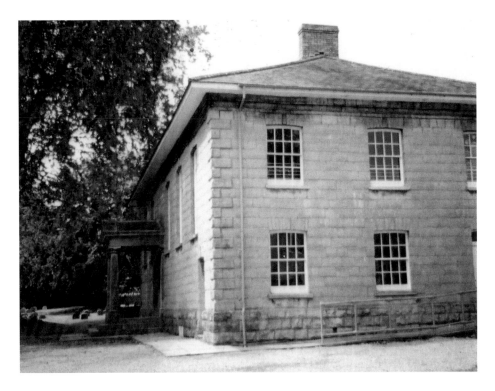

Quaker Meeting

Walking into the gate of the Quaker meeting house is like going into a typical New England chapel. The same kind of 'burying ground' of little modest gravestones, uniform and bereft of ostentation, lies beneath a huge ancient tree outside a charming small chapel. Though it dates only from 1850, Quakers are known to have gathered locally earlier even than the thatched building on this site. Earlier places for meeting houses included one on the NatWest bank site. Prominent family names include Morland, Clark, Clothier and others. By 1689, four private premises were officially licensed for Quaker meetings; only one year later one was also recognised at Glastonbury, where Friends had met in the Abbot's Kitchen at the Abbey.

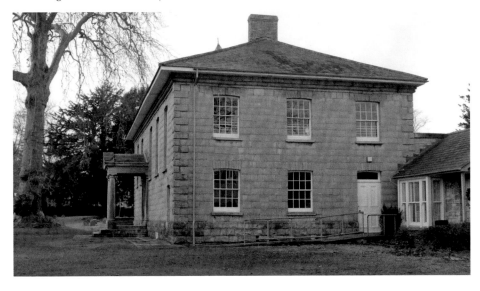

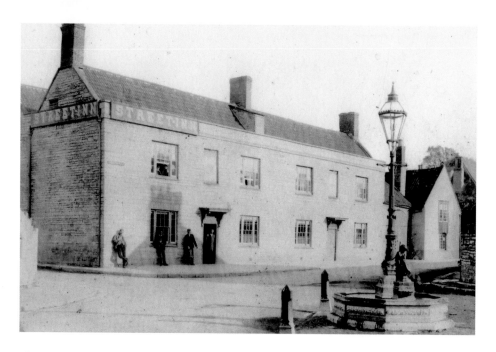

The Street Inn, c. 1920

Ever-increasing traffic eventually forced the removal of this attractive central fountain to a safer corner opposite. But here it still holds water for the last days of horse-drawn vehicles. At this time, Thomas Hecks was the landlord, and family members are looking out from an upstairs window. Landlord Hecks is remembered for his lavish Boxing Day feasts, when a massive whole side of beef was brought by horse and cart from a family farm at Chard. At a bakery opposite the inn, this was cooked in the big commercial ovens and delivered for the Hecks to carve for crowds of customers. From the local cider trade here developed the still-extant Hecks cider barn at Middle Leigh, where the scent of real 'Zummerzet Zoider' is for many locals a memory of childhood.

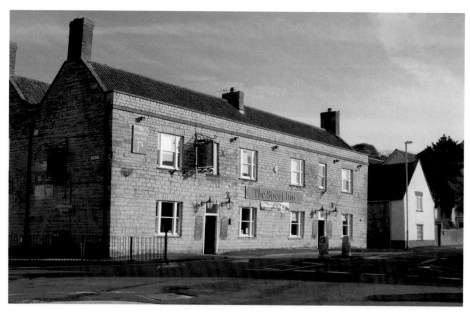

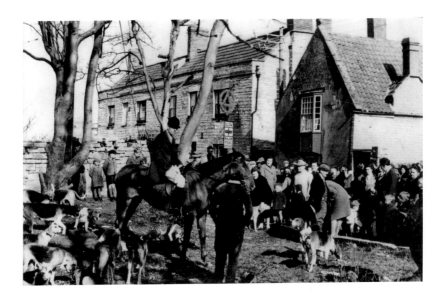

The Hunt Meets at the Street Inn, 1950

Time was when hunts met within sight of Big Ben, at a pub called the Fox Under The Hill. That seems almost unimaginable now, and so does the thought of such a scene on a busy road junction at modern Street, within but a couple of generations and as late as the 1950s. Even odder, this was a hunt based right down into Dorset, not a local one. The date was late February 1950, when the Blackmore Vale Pack gathered outside the Street Inn, watched by excited crowds. Later, someone carefully added bits of colour, by hand, making the horseman's jacket bright scarlet, and also the hat and coat of one small girl in the crowd. Was she, perhaps, his own child? Before moving off, the hunt was served with refreshments by landlord Rudlen. They did not go far before finding a fox on Millfield land, and continued as far as Pedwell. The hunt master, Brian Livington-Learmouth, 'expressed his enjoyment of hunting this fresh country'. Only the fox did not enjoy the run. Why a hunt from mid-Dorset should have come all the way to Street to start, we have not discovered.

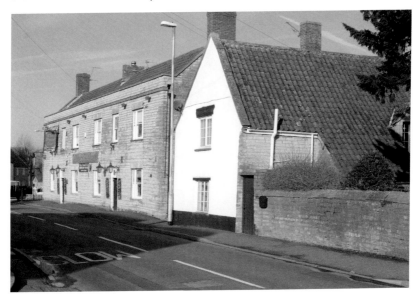

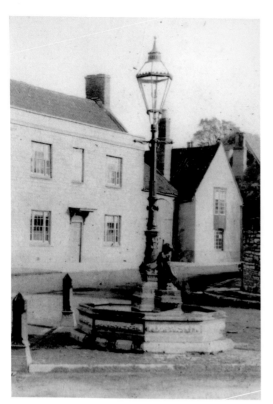

Trough at the Cross, *c.* 1918–20
Horses hauling coaches and carts, and cattle being driven through, found great benefit from this charming public fountain. Miss Ansell of Holmcroft, who financed the trough (and a plainer one at West End) specially loved horses and dogs, and greatly cared about their welfare. As late as the 1940s, the last few cows are remembered being driven along the road, but in the late nineteenth century they would be thronged around the Cross, driven in during regular cattle fairs, right up to around 1915. Sadly, any central feature stood little chance of survival against later twentieth-century vehicles, and was moved to a safer location on the corner of Grange Road, but still facing its former location. It has recently been beautifully restored, with help from a generous benefactor, and the water trough filled with flowers, planted by local children.

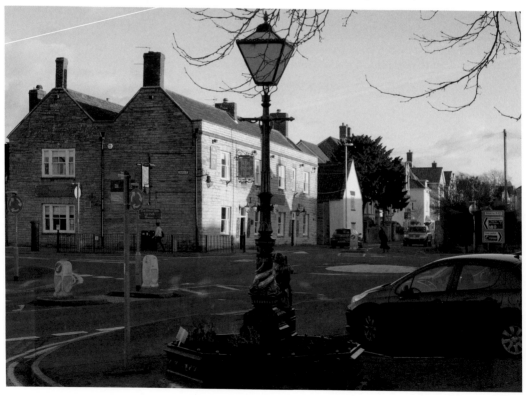

Turnpike Cottage, 1970s

The Turnpike House or Toll House marks where tolls were collected at the entrance to Street village, priced in old pennies and shillings for everything that moved: coaches, carts, flocks of sheep, loads of timber and goods from other areas. Through here ran the Turnpike, all the way from Exeter to London or Bristol. From tolls levied at each barrier, the costs of maintaining these first proper main roads were raised (in the US the word turnpike still today refers to a major highway). Before 1754 tolls were taken near Pomparles Bridge, but moved to this site at the Mead some forty years later. The last barrier gate is kept out of sight in Brutasche Terrace, away from vandals and vehicles, but is deteriorating; attention to its state is being drawn.

Somerton Road, 1970s

The right-hand house wall identifies where the much newer Wessex Close turns off from Somerton Road, and looks uphill towards Elmhurst and Millfield. One of the many benefits of moving to Street for work was the variety and quality of the new housing estates being built for factory workers' families. One of the earliest – and probably the first – of them were these on Somerton Road, erected by order of Cyrus Clark in the 1840s to house outworkers who did their shoemaking in home workshops. Taking the finished pieces to the factory once a week, having them inspected, collecting a wage and taking leather and other materials away to work on the next week, was verbally known as 'going to shop'.

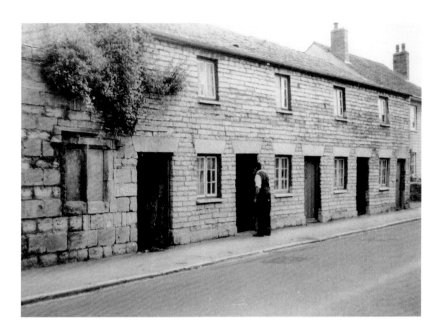

Demolition Work on Somerton Road, *c.* 1968–69

These cottages are remembered as being just above the original grand Holmcroft, which now exists as a replica frontage and other blocks of apartments. They appear in the first stage of demolition, with workmen walking in and out of the front doors. The left-hand wall appears to be much older. Did the large stones and the small window originate at Glastonbury Abbey? It is possible, as the Abbey became a gigantic quarry after the 1539 Dissolution of the Monasteries, the stones already being cut in building sizes. Innumerable cottages in Glastonbury have recognisable stones in their walls, and garden features made from other fragments. Huge quantities were used to improve the road to Wells. Some were even later shipped to Washington, to make the Glastonbury *cathedra,* or bishop's throne, for the new cathedral.

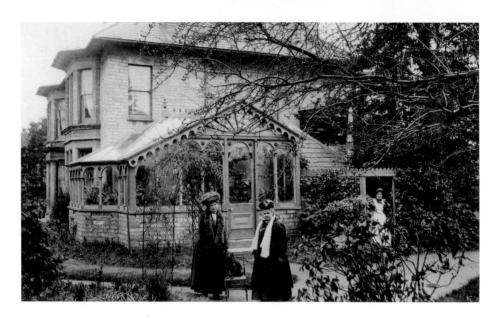

Holmcroft, Leigh Road, *c.* 1905

At least three buildings have sat on the big site just above the Street Inn. In the first of these, a pretty thatched property known as Friends Charity Farm (or House) settled Joseph Clark, whose descendants included the firm's founding fathers, Cyrus and James. Next came the grand nineteenth-century Holmcroft, built in the 1870s for Mary Ann Ansell, the public-spirited lady who gave us the delightful horse trough nearby. Her gardens were notable, as was the ornate conservatory at one side. On the reverse of this postcard, the uniformed maid in the background explains that she was watching the ladies being filmed without realising that she, too, would be captured (and published again 100 years later). For a long time Holmcroft was a boarding house for Millfield students, until recent developers took it over. Residents fought hard to keep it, but eventually it fell under the bulldozers. But all sight of Holmcroft is not lost: part of the expensive group of apartments includes a close replica of the stately old frontage.

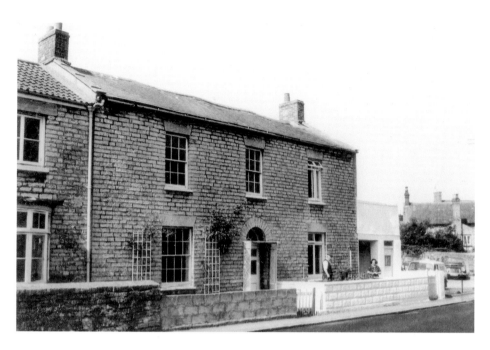

Somerton Road Near the Cross, 1960s

At the bottom of Somerton Road there is no sign of the future Wessex Hotel, lying over the right-hand empty site. That simple gap has actually seen drama in the past: the 1838 election day riot (one ringleader was a Wells Cathedral organist); constant changing of stagecoach horses when about fourteen routes stopped off here; destruction of the Hope factory that processed seed and grain; work at the next-door bakery, whose premises were later merged into Hope's for expansion; and the final 1960s burning of both buildings. On that empty site was built the present Wessex Hotel.

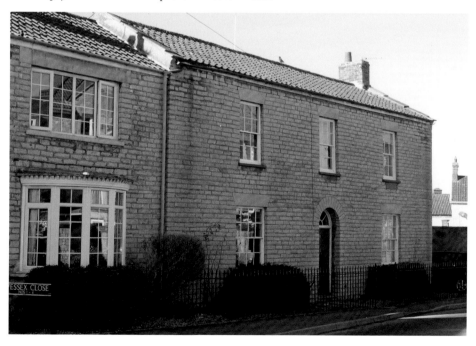

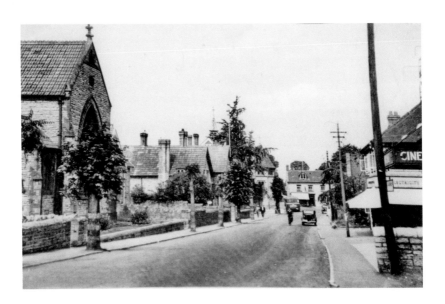

Leigh Road, c. 1946–47

A picture of Leigh Road is postmarked 1957, but appears to have been published a decade earlier, just after the Second World War. The clue is in the three white lines painted on the trees, and some walls, for guidance in the nightly blackout. No street lights were ever switched on, so pedestrians walked with small hand torches, believed to be too small to be seen from the air, which could pick out any white markers, also including kerb edges. Hidden by a tall tree, the now redundant air-raid siren may still have been on the Crispin Hall roof. The utterly ear-splitting noise made Streetites (not our posher Streetonians) at the bus stop wonder if even a blitz was worse. Had they actually risked going into Bristol in the 1940s they would have known better. One day a Street dealer in farm feeds set out for Avonmouth docks. Hours later he returned, his load undelivered. At the kitchen table he sat and sobbed. The customer was gone, along with his premises, the whole street, and road after road was just rubble. That was what the sirens were really about.

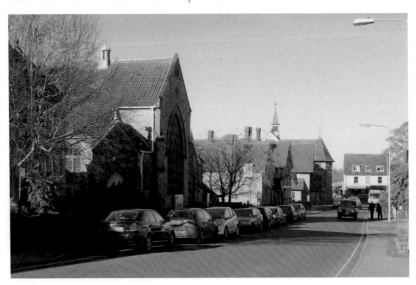

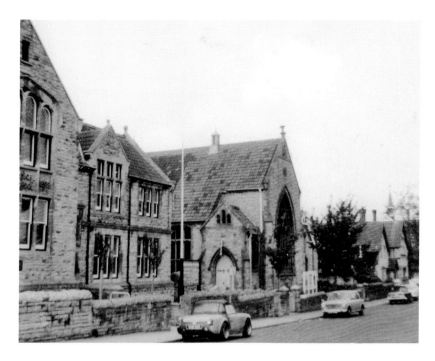

Leigh Road, 1980s

Unofficially, Leigh Road has been nicknamed Civic Road from the number of public amenities erected between the reigns of Victoria and George V. On one side are the library and former cinema. On the other side they range downhill from Hindhayes School and House, past the attractive corner group of the first Strode School, which later became a medical centre, the 1899 Technical School, the Methodist church, the former police station, the Vestry Rooms (now the home of the parish council) and finally to Crispin Hall. The church of 1893 has a beautifully light and bright interior and a very fine organ. Its main hall, round to the side, is currently used for Street Society meetings, among other events.

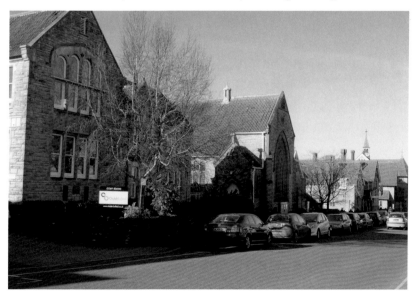

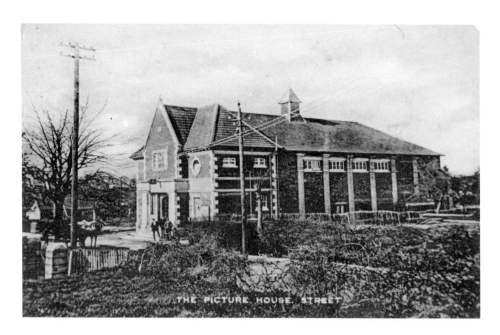

THE PICTURE HOUSE. STREET

The Cinema in 1920

A postcard used for a birthday greeting in 1924 shows that the cinema, when built in 1920, was the earliest public building on this section of Leigh Road. Either side of it is still rough land and brambles. Where today runs a stream of cars, buses and lorries, just a few doorstep loafers, plus one man with a horse and cart, are the sole signs of life. Unlike the church, educational buildings and other civic buildings on the facing side of Leigh Road, it bucks the trend of using grey Polden stone for most amenities in Street, by using mainly brick. The Picture House changed names later, including the Playhouse and the Maxime, finally becoming the Envy nightclub; all of them rather more flattering than the early nickname 'The Bones and Beer'. Bones came from Mr Voake, the butcher, and Beer from Mr Hecks, the maker of cider; these were the two businessmen behind the erection of the building in 1920.

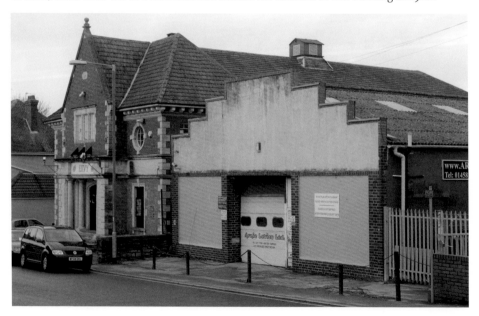

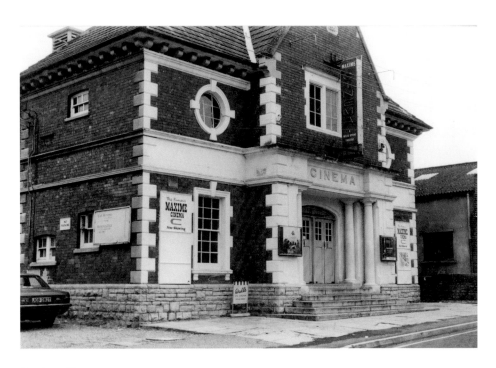

Maxime Cinema, 1970s

Despite being advertised as 'The Famous Maxime Cinema', cinema-going was already declining nationwide. The rise of television seemed to be the death of 'going to the pictures' before our present-day revival. The reverse of the 1940s when entertainment outside the home did so much for morale with both drama and topical wartime comedies like *Gasbags* and others poking fun at Hitler. Changing into a nightclub saved the building from demolition.

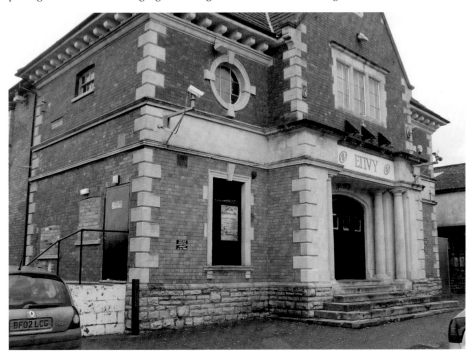

Hindhayes, Early 1970s

Looking upwards from the High Street into Leigh Road, the charming house called Hindhayes closes the view like a statue at the end of a promenade. Apart from its unusual outline, its mini public park of a front garden, and a massive wisteria covering much of the Leigh Road side wall, it is noted for being built for a farmer whose sons became the founding fathers of Street's famous industry. Two of them were Cyrus and James Clark, whose initials 'C. & J. Clark' became the products' logo. It also gave the name and location to Hindhayes School. Between the end of the garden and the gate of the school stands a now rather battered old kissing gate. From here a footpath leads across an open meadow with views to the Tor, directly across to Elmhurst and Millfield schools. Truly, this is a community where education has flourished right from the first little National School through to today's Strode College, to which students are bussed from many miles around.

Hindhayes Infants' School, 1928

When it was opened in 1928, Hindhayes infants' school was way ahead in promoting fresh air for health, built in a unique colonial manner in the shape of a cloister. Each classroom, just one room deep, had tall glass doors instead of just windows, on two out of four sides. Those panels could be opened right out, on one or both walls. Round the inner side was a deep, shady verandah, enclosing a lawn and tiny pond. Even healthier, in hot weather the children's little chairs could be moved right out, each class in a group with a teacher. There were once even tiny camp-beds so they could lie down and rest in the air at lunchtime. School milk also played a part with little bottles in a 'gill' size put in a crate outside each room until break-time – fine until the notorious 1940s winter when, leaving their now enclosed and warm classrooms, the children found each milk portion was solid ice. Any bottle dropped on the ground would smash and leave frozen milk in the same shape, minus glass.

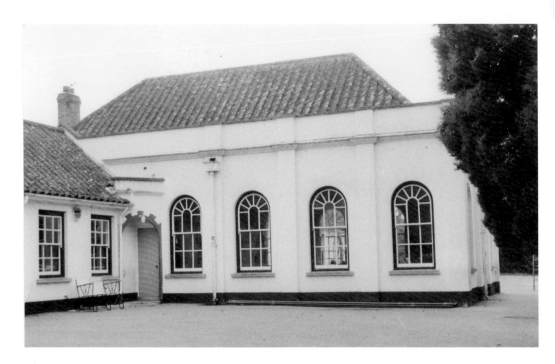

Hindhayes School Hall, *c.* 1972

Former pupils still recall, from infancy, how the clock in the hall gave a loud crack when a hand touched the top of the hour. Others remember the mottos carved above the fireplaces that predated central heating, such as 'Manners Makyth Man'. Similar quotes can also be found at Crispin Hall and in the main house of Millfield. On opening day, symbolically, a six-year-old girl was to lead her classmates into the new school by unlocking the entrance, but her infant hands needed the architect's help to turn the key.

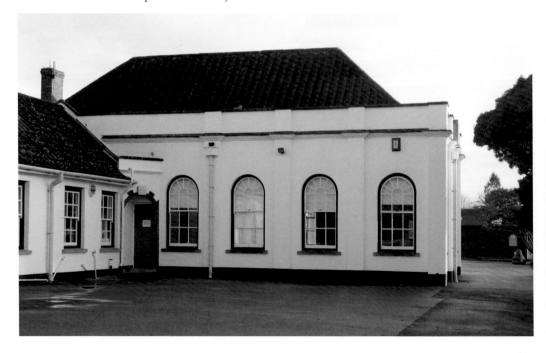

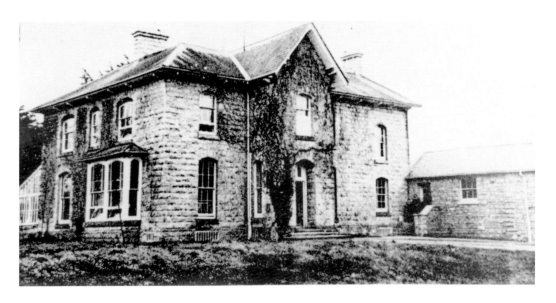

Elmhurst

Cyrus Clark's own house, Elmhurst, is best known to posterity as a school, architecturally a close counterpart of Hindhayes. Old girls in particular affectionately describe the summer uniform: a pale green cotton dress with buff collars and cuffs, worn with a scarlet blazer and black bindings. As for educational standards: when it was Elmhurst Grammar School, one old girl tells of being transferred to a London-area school whose headmistress implied that the country bumpkin would have to work hard to catch up. Instead, she was found to be a whole term ahead of the other children. It was *she* who must mark time while *they* caught up.

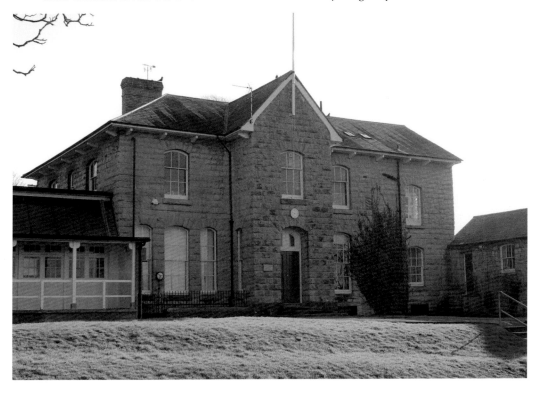

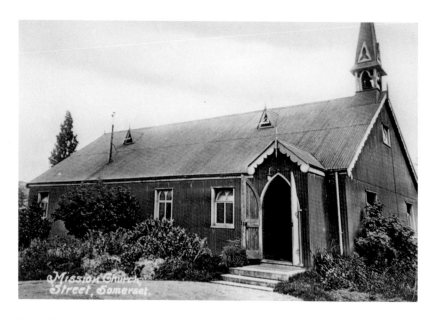

The Mission Church ('Tin Church'), *c.* 1930

Corrugated iron temporary churches, nicknamed 'Tin Tabernacles', frequently appeared when Victorian villages suddenly expanded and grew away from the aged parish church. Such was Street after the opening of Clarks' factory brought workers in, lured by the philanthropic attitude towards their employees. Holy Trinity was ever farther away from new roads. The answer was the pretty 'Tin Church', whose next-door rectory was actually more permanent than this church. In 1897 the Bishop of Adelaide (in England for a Lambeth Conference) laid the rectory's foundation stone, being the Revd Somers-Cocks' brother-in-law. Putting this stone rectory first made sense. Street's rector was accommodated in a rented house instead of a church building. As a stop-gap until the Tin Church was completed, this new parish took over the Salvation Army's first little hall behind the High Street.

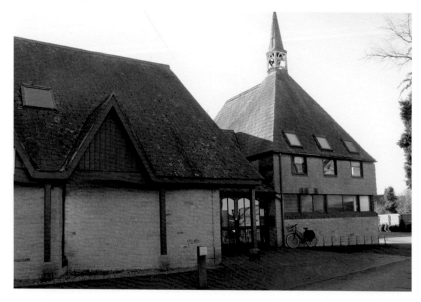

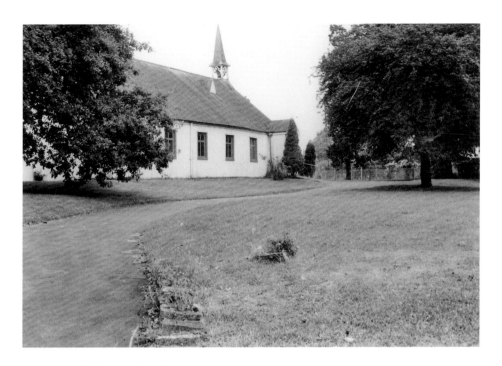

Last Days of the Tin Church

By the time this picture was taken, in the 1970s, the Tin Church was declining. Supposedly temporary, it eventually lasted eighty-odd years. No longer looking immaculate, it nevertheless kept a certain charm. When finally replaced by the present brick building, a number of former fittings were kept, including the dainty single bell turret on top, to remind any Streetonians of childhood and Sunday school. The small organ, too, lived on in the replacement church well into the twenty-first century. It was still pumped by hand well after the Second World War era.

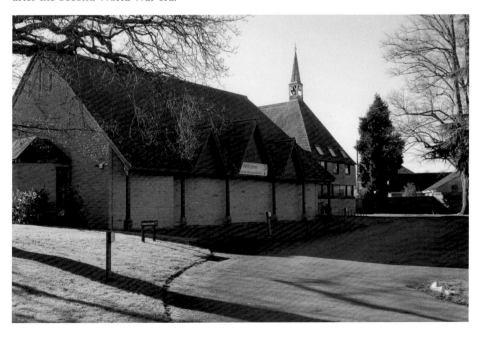

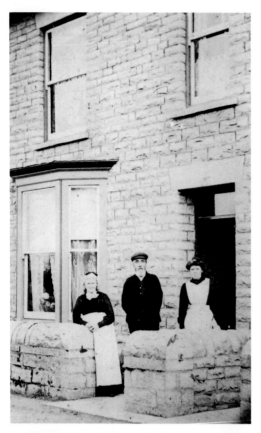

Cottage on Stone Hill, *c.* 1915

Stone Hill area has been increasingly built up during the last years of the twentieth century, with new roads replacing orchards and former gardens. Yet various Victorian and earlier cottages stand between the new homes, including a tall block whose frontages and traditional Polden stone walls look much as they did when the writer's great-grandparents lived there. Alf and Mary Ann Searle (*née* Penn) are with their daughter Nan from Gladstone Terrace, one of the last Clarks' outworkers, making trimmings for ladies' slippers and gloves.

Peck Mill, 1974

Just a year ago, in the winter of 2011/12, this view from the end of Stone Hill towards Peck Mill had scarcely changed since childhood. The author could still identify the grass patch where her mother had laid salmon sandwiches on a cloth, carried from home, only to abandon it when a cow poked its tongue over her shoulder and grabbed a tasty snack. Now, writing on New Year's Eve 2012, this rural scene is changing forever. Not only is a large housing estate being built; even the general view is gone behind a massive wall, too tall for most people to peer over, of endless length. Residents with pre-war memories can describe chickens clucking around inside the old farmhouse, on ancient Polden stone floors, or feeling almost seasick when taken upstairs where the creaking floors dipped up and down at alarming angles unknown to modern housing. The Mill itself was half buried in overgrown foliage, and a couple of planks formed the only bridge over the small stream. Since then, of course, that sense of disorder has been banished by restoration. All looked well in this scene from the 1970s, until...

Footpath to Street Hill

From the farthest end of Stone Hill, beyond where driveable roads turn away, a short, rough cart track, a five-bar gate and a stone stile led onwards by a pretty footpath up to Street Hill. The meadow grass was kept short by grazing cattle, and through the rough hedge were intriguing streams with wild mint growing. New housing estates have since then encroached into the idyllic scene.

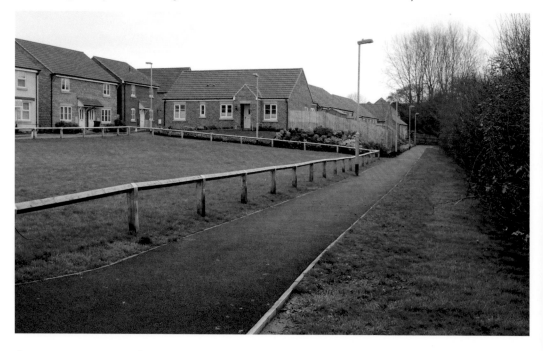

Far End of Stone Hill, 1999

For decades after the author's childhood, a favourite gateway seemed unaltered; the same rough track, same old stone stile, same fence, same glimpse of the field beyond. Even when *Street Through Time* was in the planning, little appeared to change. And then, just out of the picture behind the camera, almost everything was changing in a rush. Up went the 'New Homes For Sale' adverts, workmen moved in, dozens of new houses began to take the place of ancient hay meadows, and a massive wall was erected to enclose the estate. Would this last fragment of old Stone Hill be spared? We are still unsure. Meanwhile, memories manage to linger above the noise of the workmen: of climbing the stile and running round the back of the left-hand sheds to watch a whole row of sows with their tiny piglets, and to see the cider apple trees which were eventually turned into true Somerset scrumpy, more potent than any modern commercial cider. The smell of it fermenting was unforgettable.

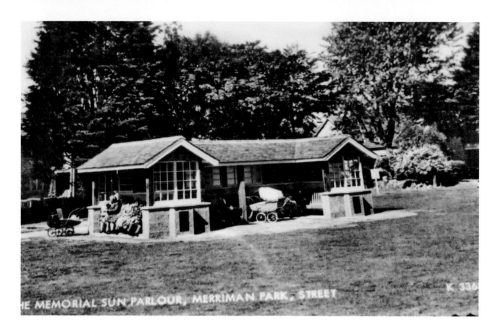

THE MEMORIAL SUN PARLOUR, MERRIMAN PARK, STREET

Merriman Park

The name of Merriman covers an area uphill off the High Street, wrapped around Merriman Park, Road and Gardens. They honour the Revd John Xavier Merriman, who was born in 1841, to the vicar, Revd James Merriman. James was so keen to understand his parishioners' lives that he took up shoemaking himself in a home workshop. Later he became Archdeacon and third Bishop of Grahamstown in South Africa. His son, 'John X', also entered South African politics and became Prime Minister. Only the bottom part of the Memorial Sun Parlour survives, but the original was very typical of public park buildings. Mothers could sit and chat and knit while watching over their offspring on the swings and slide, with their youngest in elegant babies' prams instead of our modern buggies.

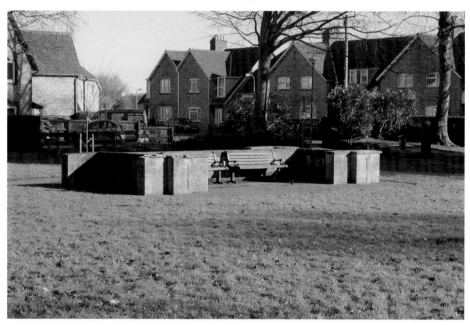

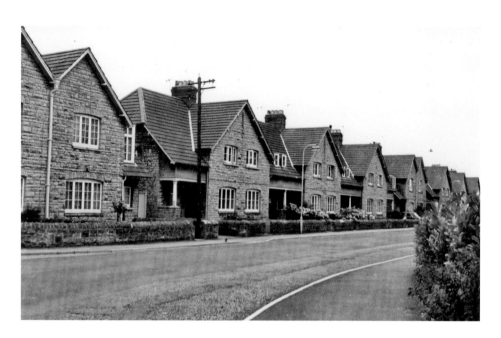

Merriman Road, 1970s

Merriman Park is almost encircled by two streets of the same name: Merriman Gardens and Merriman Road. The latter consists of very fine-looking buildings that one would not take for council housing at first glance. Built of rugged local stone, they have deep porches and shapely roofs that give such a sturdy appearance. As elsewhere, council houses were later sold off at advantageous prices if tenants wished to actually own them. Some roads thus still consist of privately owned homes and council ones, often adjoining. Vent tiles on the roofs, a council improvement, are an easy clue as to which is which. Initially, just before the First World War, it was realised that Street lacked such housing, and the council acquired land called Burts Orchard to build Merriman Road.

Merriman Gardens, c. 1969–70

Merriman Gardens, off Merriman Road, bucked the trend of building mainly from Polden stone, plentifully available from several quarries around Street. Stone had been as typical of Street as was Highbridge or Bridgwater brick, brought in by train, at Glastonbury. Here the two materials are artistically combined: stone for the main house, ornamental brick details around windows. Just over fifty of these houses were planned in 1920. In this and several other roads of one-time council houses, ownership has gradually changed, as individual homes were put up for sale. The original tenants, of course, could enjoy Merriman Park when it was most used, able to hear music from the bandstand without even leaving their front gates. The bandstand was opened by Mrs John Bright Clark in 1927. When new boreholes were excavated on the Mendips to support Street's waterworks, some of those lengths of rock, too good to dump, were brought to Merriman Park and used as garden features near the main gate.

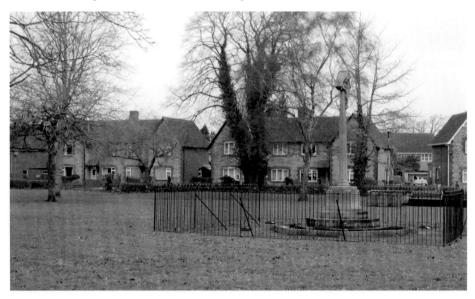

Oriel Road, 2001

What a difference a mere twelve years can make! The houses themselves are little altered, but the gardens have filled with shrubs and trees. This group of three houses is named Oriel Terrace, as part of Oriel Road. One of the Impey family is believed to have come up with this name when the road was developed in the early 1920s. The word 'Oriel' signified somewhere facing east, into the rising sun, and the entire set of about twenty houses were built on just one side of the road with an eastern face. Memories are told of the opposite side, except for the Tannery, being then still open land, but since filled in with various newer properties.

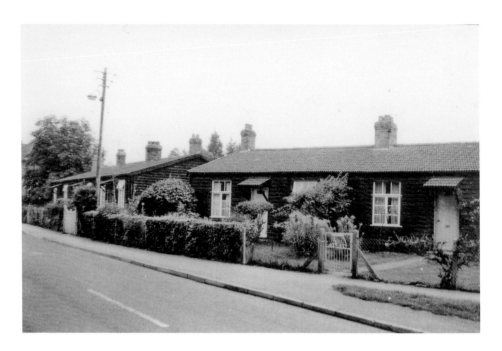

Wooden Cottages in Farm Road, Early 1970s

Surprisingly little seems to be known of these picturesque wooden cottages on Farm Road. As far back as the Second World War years they were thought of as old. During the First World War similar timber houses appeared in other places, for such uses as troops' accommodation or army hospitals. The 1940s version of such buildings appeared uphill on the Batch for billeting the many troops who passed through here for training before being posted to Europe: Americans, Canadians, Poles and others. Some met and married local girls and never went home, hence the number of local Polish surnames. Similarly Italian prisoners of war sent to work on farms account for the many Italian names in this locality. Whatever their origins, the Farm Road cottages continue to puzzle and charm.

The Grange as a School of Housewifery

Colleges for girls to learn the higher grades of housekeeping, so as to get good jobs in service, proliferated in the late nineteenth and early twentieth century. Instead of starting as a little skivvy or kitchen maid, a girl with formal training could apply to the wealthier employers and become, perhaps, a housekeeper, cook or lady's maid. The Grange was typical of these schools, titled a School of Housewifery. Each year an open day was held, demonstrating the range of subjects taught, and the level of the students' work. The complement as recorded in the 1920s was just thirty girls. Up to 400 girls were educated at The Grange in its first fifteen years, all of them fitted for service in the best houses.

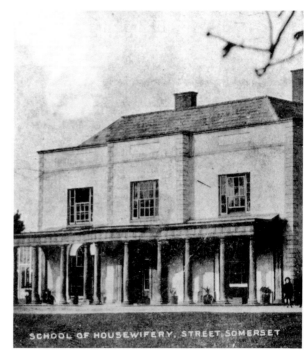

SCHOOL OF HOUSEWIFERY, STREET, SOMERSET

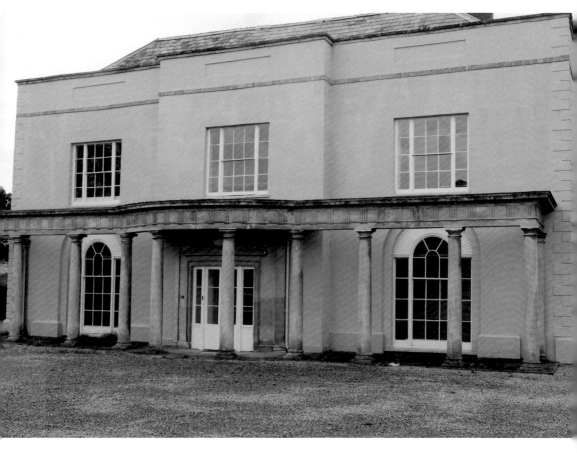

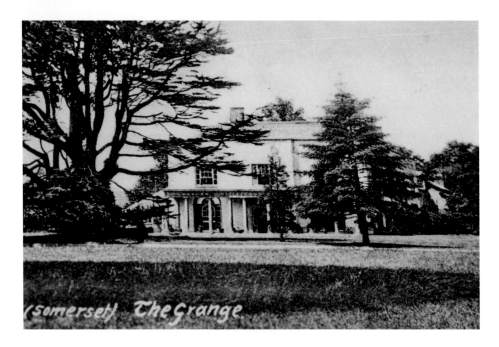

The Grange, *c.* 1905

Postmarked September 1905, a card was sent to a farm near Frome. 'This on the other side is our school,' wrote Winnie to Daisy. 'My address is The Grange, Street, Nr Glastonbury.' She was presumably on some course in domestic economy. Like most local picture postcards and studio pictures, the house is portrayed by Higdon's studio. His firm sold great numbers of cards when they played a part soon to be overtaken by the telephone. Rarely does a historic card cover more than some trivial everyday message: Will an order be ready tomorrow? Can you come to tea? Is Mary's cough better? Daisy must have been a recent arrival, keeping a promise to say that she is 'quite happy here' and to send a card.

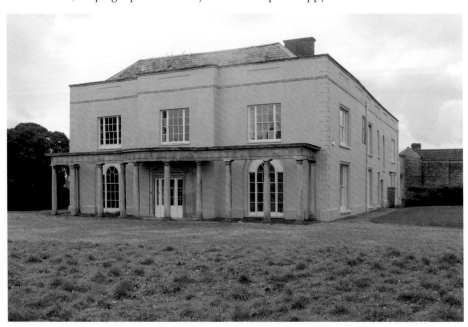

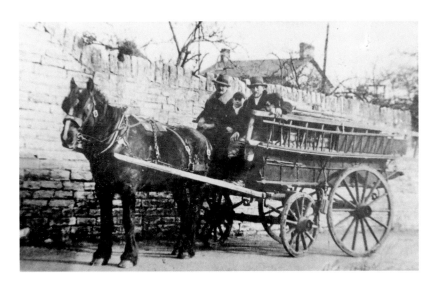

Peat Workers in Farm Road, 1934/35

Higdon the commercial photographer's name appears on numerous local pictures: picture postcards showing ordinary roads as well as civic sights, studio portraits, weddings, gatherings and formal events. His postcards tell us a lot about everyday life and people in pre-Second World War Street. Here Higdon has recorded a peat worker's cart in the winter of 1934/35, seen on Farm Road. The child, in later life, gave details about his family and their working lives. Jim Payne, aged nine, is flanked by his father Ernest Payne and (smoking) Ernest Giblet. Giblet helped the Paynes with ditch clearing and peat cutting through most of his life. The vehicle was described as 'the standard peat-hauling wagon for road work'. A whole day with peat, usually at Westhay beyond Meare, was hard physical work, with just a cold meal for a midday break. This was known as a 'dinner pack', dinner being the word for what is now lunch, rather than an evening repast called tea or supper. Close by stood Street Farm, built around 1830 for the owner of the Grange lands. But by the 1890s, it was in Clark ownership, latterly used for such jobs as storerooms.

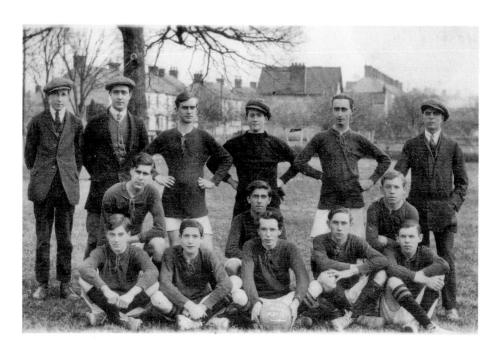

Football at Woods Batch, c. 1917

Street Rovers could still field a team during the First World War by combining players too young to fight, along with men above military age. But how many of these front-row youngsters were still to be called up when the war still had about a year left to run? The ball is inscribed for the 1916/17 season. Some names are on record. Back row: ? Nicholls, Herb Miles, -?-, Doug Hopkins, -?-. Middle row: Arthur Martin, Forbes, -?-, George Pursey. Front: -?-, -?-, Chris Osmond, Bill George, Percy Parsons. They are believed to be posing in their playing positions in that day's match. The Batch has been a popular open space for sports since 1906, a decade before the Rovers picture was taken. In the background are houses at the northern end of Cranhill Road.

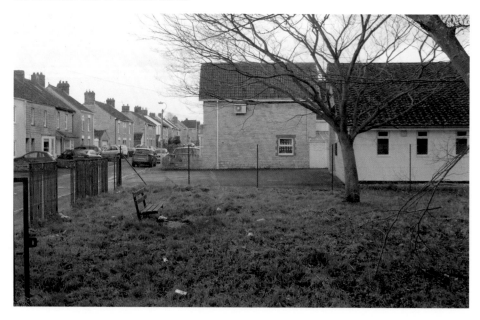

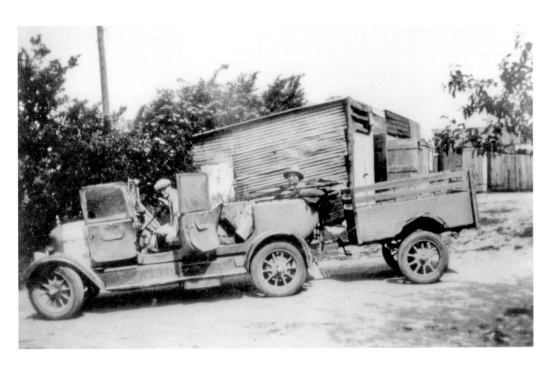

An Animal Feed Store at Higher Brooks, 1923

Pat and Will Searle (father and son, also seen on another page at West End) have progressed from a horse and cart to an open car with pig trailer for carrying anything from livestock to logs or chicken feed. The wooden shed stored hessian sacks full of cow-cake, and had a few indoor chickens for family eggs. Other hens scratched around outside. The shed continued well after the Second World War, only to be burned down by a disturbed arsonist.

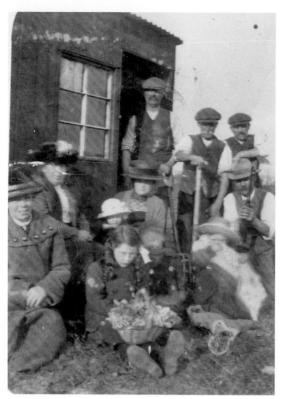

Higher Brooks, *c.* 1905
'Some of the folks at work on the new Brooks Estate,' reads the message on the back of a snapshot, in the author's grandfather's writing. Being a great wise-cracker, the 'Estate' must have been only a quip, as the wooden building was just a single-storey store for animal feed and other farming sundries. It was a family DIY job, with children brought in to watch and help. Their names are not recorded, but the girl in front, with a basket of wildflowers, appears in various other pictures of Street from around 1903 onwards.

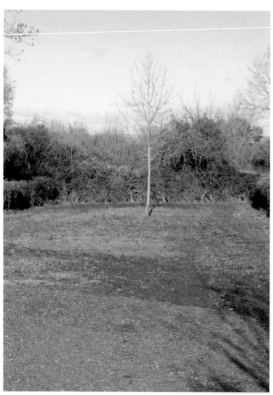

Facing Avalon Leatherboard, *c.* 1969–70

Directly facing the Leatherboard Mill, all alone on its side of the road, stood this substantial country cottage, with its traditional Polden stone walls and open land to its side and rear. Though this photograph dates from the late 1960s or early 1970s, the peaceful couple ruminating over the gate, and their stone house, could well have belonged to a photograph album of several decades earlier. Could they have dreamed that, in little over one future generation, their idyll would be nothing more rural than a car park?

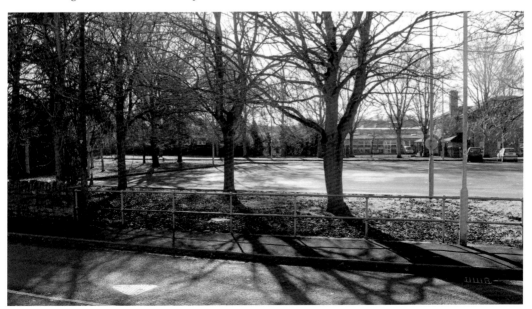

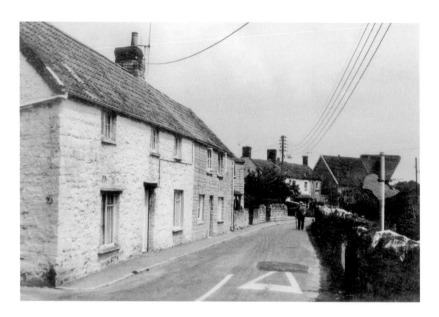

Overleigh, Early 1970s

'Leigh' or 'Lee' in a place name usually means a gently sloping open meadow, and is pronounced as in 'flee'. A whole series of leighs drop downhill from Overleigh, Leigh Holt, Middle Leigh, and Netherleigh, right down to the High Street. Some had to be different and pronounce it as 'lie'. Though the lee version is most common, some more historically aware folk cling to the lie pronunciation, even today. Whatever we call it, Overleigh is, naturally, at the higher level, and was rural and remote until the 1820s; just farms and fields. But when one of the Clark family more formally gave Overleigh as a name for their farm, the title gradually attached itself to the area in general. Even now, in the twenty-first century, Overleigh remains as a hamlet in its own right, picturesque and charming even though it begins off the busy main road up towards Marshalls Elm.

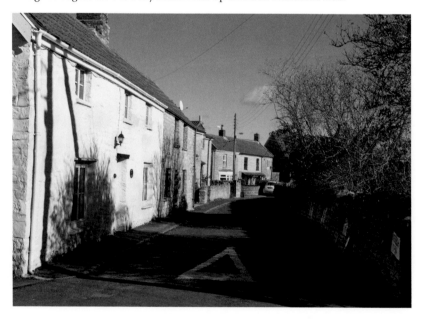

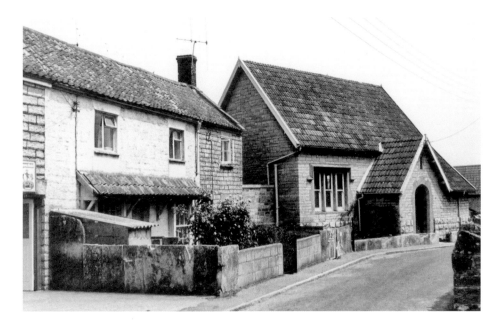

Overleigh, *c.* 1972

Another view of the charming, little old community at Overleigh, showing the traditional use of great flat slabs of Polden stone to form a wall. The top one, nearest the front door, is taller (for privacy) with a curved top edge, another characteristic. Conveniently this stone could by nature be extracted in these large flat pieces from quarries which existed all around Street. They could be stacked up on end together, like massive playing cards. The smaller stones sat individually on top of walls as ornaments. Even now, such walls appear outside new buildings. Street's stone quarries also revealed wonderful fossils, as the banks were opened for digging. One ichthyosaurus measured nearly 8 feet (around 2.7 metres) in length, and such a creature's skeleton is still our official logo, as an inland Jurassic Coast.

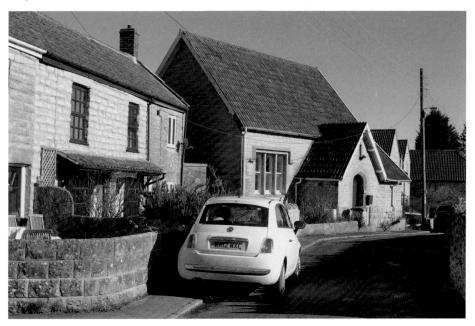

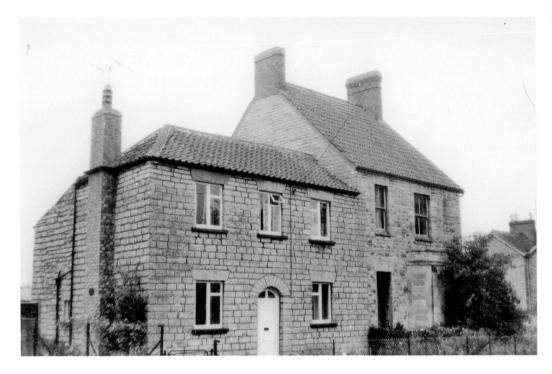

Houses in Farm Road, Early 1970s

These two substantial stone houses stood on Farm Road, just beyond the Royal British Legion buildings. When this deliberate record-shot was taken by a Streetonian who was very aware of change, they were already doomed. The bay window of the larger house has clearly been bricked up for some time, awaiting the demolition man. No trace of them now survives.

Cottage at Kingstown, *c.* 1971

The roughly hand-painted notice 'Budgerigars for sale' gives a hint of the date for this pretty Kingstown cottage, for the price has been blacked out and changed from 10*s* to 50p. Decimal currency must therefore have been relatively new, the official changeover being in February 1971. At that point both old and new coins were acceptable, a 50p coin being the same as 10*s* after Decimal Day. So many other Kings built round the property of the earliest settler, Robert King, in the 1820s that the hamlet became Kingstown.

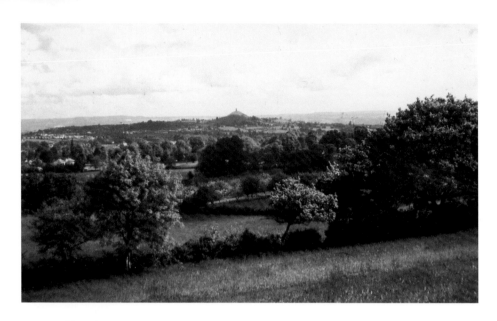

Street Hill, 1969

What a difference a few decades can make to a view. In the 1960s the panorama from Street Hill shows little sign of post-war expansion. Most of Bove Town, above Glastonbury, looks green; now it is virtually a place in itself. Nearer the camera, the huge shoe warehouse is not even a thought in a planner's notebook, and the new housing estates have not yet arisen. This scene thus remains much as people old enough to remember Victory Night in 1945 saw it, when beacons were lit all over Somerset. Gathered in hundreds around a huge pile of timber, old furniture and, of course, redundant blackout curtains, they saw a tiny pinpoint of flame far off on the Mendips. That was the signal to light the next one and the next until it was Street's turn, whose message then went to Compton Dundon and on towards Dorset. Finally, well past midnight, they hiked all the way back to Crispin Hall join in the hokey-cokey and a conga.

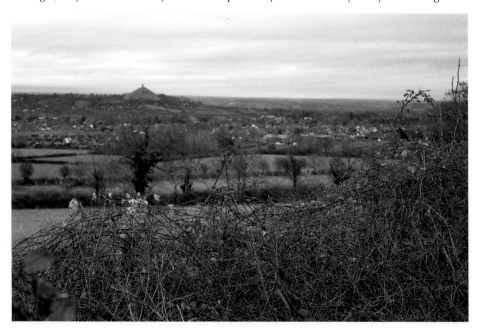

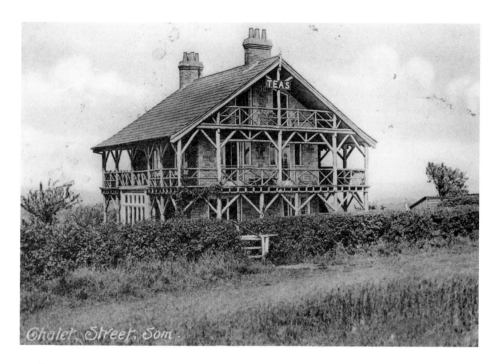

Ivythorn Hill Chalet, 1920s

The building known to locals simply as The Chalet has been a youth hostel since 1931. The balconies at this time are still of the 'rustic' timber which was so popular for fences, ornamental bridges, and seats in public parks. Stories survive of inter-wars hostellers taking moonlit hikes from here, each carrying a torch, stove, hamper or cutlery for making breakfast at dawn on the Poldens. Also remembered, around the 1940s–50s, is going around the side to buy snacks and cups of tea or bottles of Tizer and lemonade. The word 'Teas' high up on the gable confirms this service to local walkers and children.

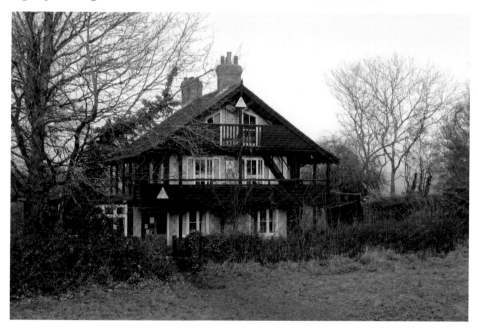

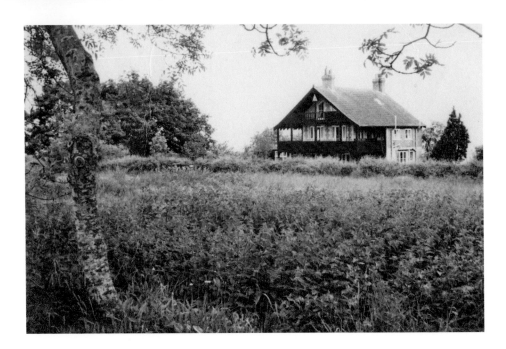

The Chalet's New Balconies, 1974

In this 1970s picture, the picturesque 1930s rustic fencing has changed into solid timber, and the 'Teas' sign has gone. On this open stretch of the hill, wildflowers proliferate. The prominent botanist Victor Summerhayes, resident orchid expert at Kew, knew where to find the rare bee-orchid, show it to relatives, and then cover it with grass so as to be less obvious. The catch-question, 'Can you see the sea from Street?' can be tested through gaps in the trees, late on a clear afternoon in the right conditions, when the sun comes into line with the Bristol Channel near Burnham. The Chalet dates from 1914, built for the charitable Impey sisters, Ellen and Catherine, for holidays and convalescence for people of 'limited means'.

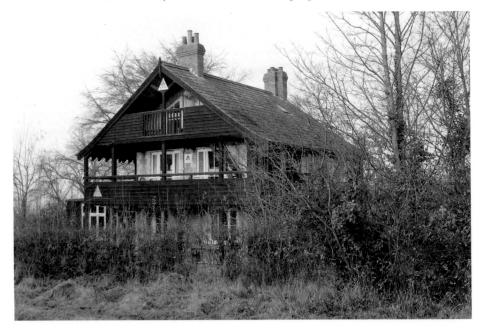

Marshalls Elm Crossroads, 1940s
These walkers had the same choice of objectives as do their descendants, on a fine day in autumn. The lady holds a spray of Travellers Joy or wild clematis, which turns to bundles of fluff around October. So, maybe straight ahead past the Chalet and Ivythorn Woods to the wonderful views from Street Hill, and onwards towards the windmill? To Compton Dundon? Towards Butleigh? The meadow behind the farmhouse was for finding spring cowslips. There was Butleigh Monument itself for a destination. There has never been a lack of places to go from Street.

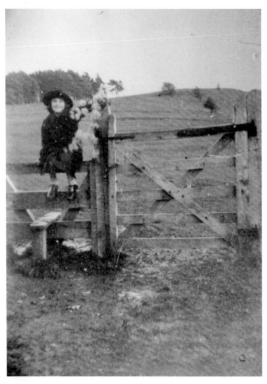

Collard Hill, 1940s

A peaceful scene at Collard Hill belies the traditional tale-telling that supposedly accounted for the name. Both Collard Hill and Marshall's Elm, facing each other, have grisly histories, through the hanging-tree elm, the gibbet and one Farmer Collard who murdered his wife and daughter with a farm implement. Supposedly he was moved from the Ilchester Scaffold to the Marshall's Elm location for swinging criminals' corpses to deter other offenders. Much more recently the hill has become famed beyond its local area as a sanctuary for a rare blue butterfly, carefully introduced here as a suitable habitat. Naturalists come to see them in summer. Locals can be even luckier if they get the very occasional glimpse of a stray. One has been seen as far off as Middle Leigh.

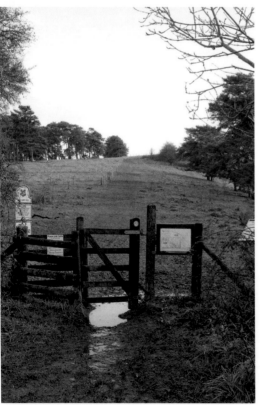

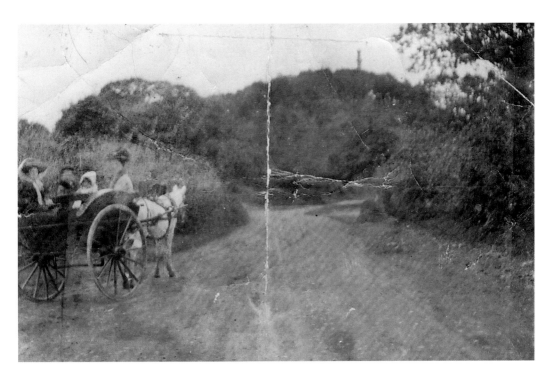

Road from Marshall's Elm to Butleigh, *c.* 1910

It is hard now to imagine a family parking their pony cart on this busy highway, while the driver gets out to pose a family snapshot. They would have driven up from West End, probably to picnic at Butleigh Monument just ahead. Some say that simple refreshments were once available there, and that many families spent a Sunday afternoon just enjoying the view.

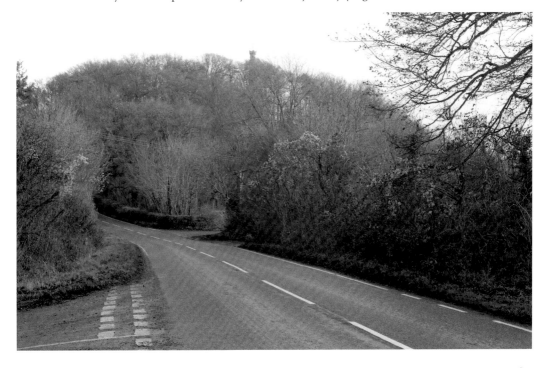

Near Marshall's Elm, 1955

Not far from Marshall's Elm crossroads, on the way to Butleigh Monument, little old Blackie almost blew up soon after she was pictured on that same road in 1955. The owner had saved and saved so that when she retired she could drive her ageing parents around their most beloved area. Blackie went to the great scrapyard in the sky several decades ago, but the birch wood in perhaps her last picture is the same today.

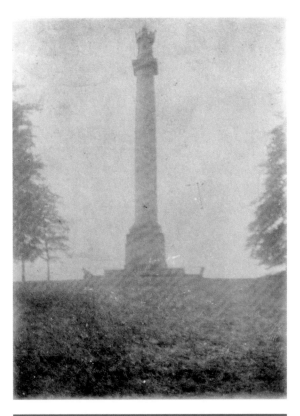

Hood Monument, 1923

Verbally we tend to speak of Butleigh
Monument rather than the more correct
Hood Monument, and count it as part
of Street, rather than Butleigh village
which is some distance beyond. Even
now Butleigh is still a village that grows
less obviously than most, yet back in
the eighteenth-century mind it was 'Our
town of Butly' in Defoe's account of the
Great Storm of 1703 (when our bishop
and his wife were both killed by falling
masonry in their own palace at Wells).
The person who gave details to Defoe
had to apologise for lack of contact: 'Our
town of Butly lies in such a place that
no post-house is in a great many miles
of it.' That could hardly be said now.
The hilltop Hood Monument dominates
the landscape for miles around. Admiral
Sir Samuel Hood, relative of a vicar of
Butleigh, is honoured in this massive
column topped by a 'naval crown' with
an outline like a ship's. Its completion
also marked William IV's Coronation.

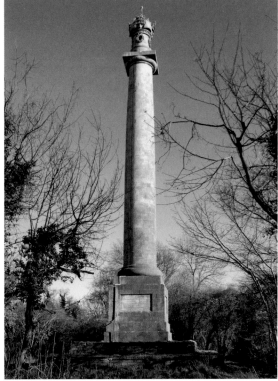

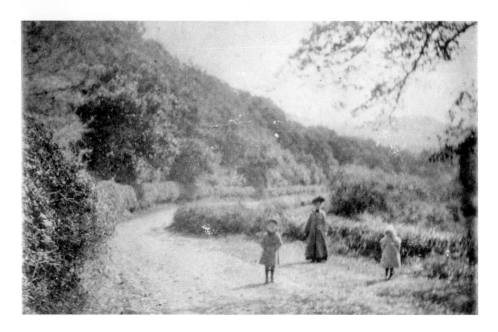

Near Marshall's Elm, 1912

The high angle of the camera is explained by the family's transport, a pony and trap which is parked near Marshall's Elm. Dad is perched above on the driver's seat for a good view, while Mother poses their children, the boy actually standing in the road. Cars coming up from Compton Dundon would not allow such a pose now, but nature's woods and hills are still identifiable. Knowing how children enjoy the gruesome, had Daddy previously stopped just above at Marshall's Elm crossroads to point out the famous elm that had been a hanging-tree? Their descendants certainly recall being pleasantly scared by tales of Sedgemoor survivors being caught and hanged from its branches: dozens of them, according to possibly exaggerated legend. The farmhouse itself was once an inn.

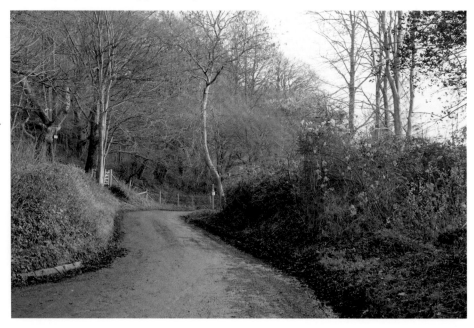

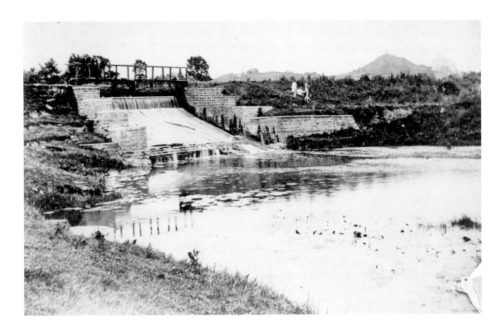

Clyse Hole, 1903

Skinny dipping is no modern invention. Though ladies might swim from a bathing machine weighted down by full daytime dress and even a hat, men are known to have bathed in the altogether, not always discreetly. Clyse Hole on the River Brue was the Glastonbury and Street answer to Brighton Beach, where youths swam and played a long way off any public road. Naturally there was plenty of horse play, which equally naturally sometimes got out of hand. Once in a while what developed was a full-scale fight between groups gathered from each town. When the issue finally burned itself out, the Street gang trudged home, still wearing next to nothing. 'Not very nice, dear,' in one shocked granny's words. It was not very nice for any woman to see. A direct result was the opening of Greenbank Pool, thanks to a Clark legacy. Now women and girls can bathe without 'seeing anything', and boys can swim decently. More recently, the Clyse Hole sluices were rebuilt.

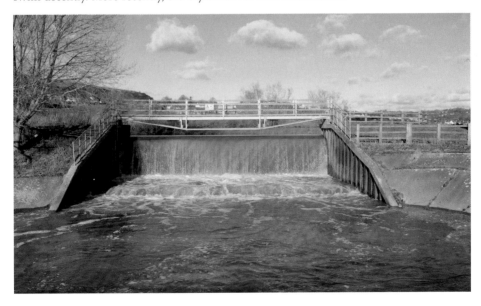

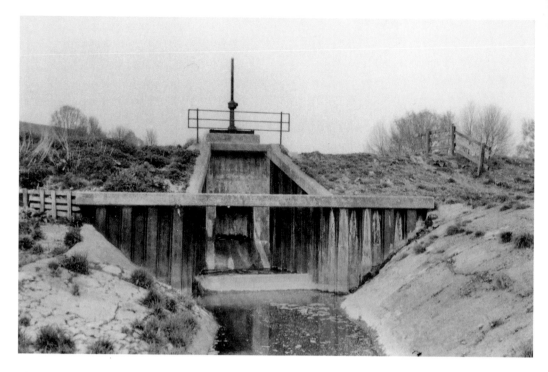

Clyse Hole, 1960s–70s

Now time has moved on, and we see the Clyse Hole sluices as they stood in the 1960s or 1970s. But whatever improvements are made, the Brue still floods to some extent. Driving out to Meare, it will be touching the very top of its embankments, and start trickling across the road. Given a deep freeze as well, shallow floodwaters in the fields may freeze into informal ice rinks that are extra safe: nobody can fall through 6 inches of ice.

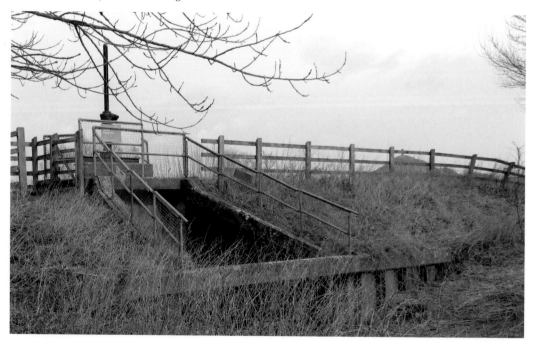

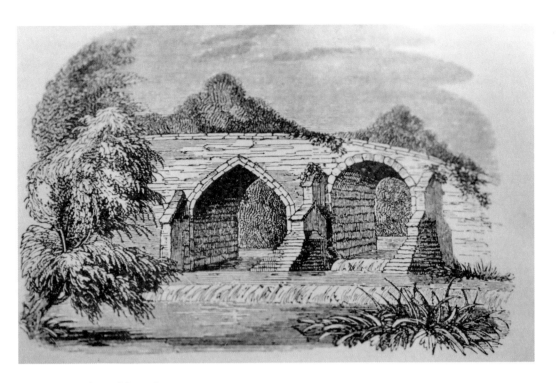

Pomparles Bridge, 1830

From a book published in around 1830 came a view of the previous Pomparles Bridge on its historic foundations. Whereas the one we know has a quite elegant and simple outline, the medieval arches fit clearly into the period when the Abbey so dominated the landscape. As far back as the twelfth century, a crossing here was significantly described as Street Bridge rather than named after its greater neighbour. Earlier still, a wooden bridge is assumed to have carried a roadway over the deeper channel of the Brue.

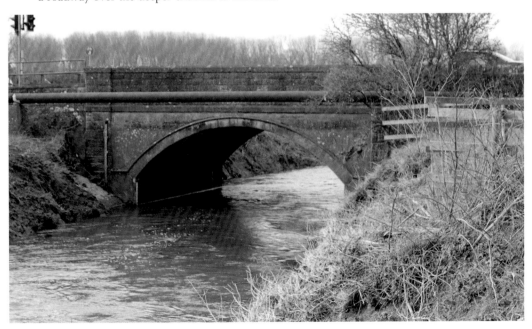

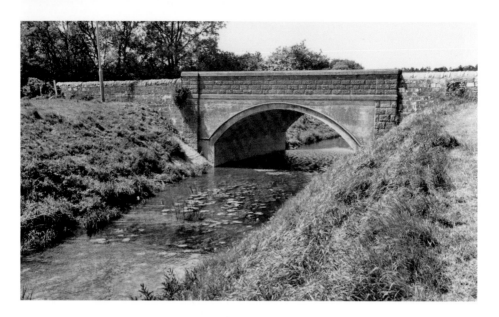

Pomparles Bridge, 1970s

Time was when a mother and children could stroll out of town towards the River Brue on the main road, and enjoy the fresh moorland breeze and views towards the Tor. Through most of the day, that would hardly be a pleasure now. Ever-increasing traffic has seen to that. Here the snapshotter has just turned off from Pomparles Bridge onto the riverbank walk that still remains popular with dog walkers as they leave the sound of traffic behind them. Somewhere here an ancient trackway was found, following a similar route to the present main road, which had linked Glastonbury and its Abbey to its neighbour. Such old, dry causeways through boggy ground often keep their former name of a 'strete', a possible derivation of 'street'. Did King Arthur throw the great sword Excalibur into the inland lagoon from this place – the Pons Perilis, or perilous bridge – where a mystery hand caught it and took it beneath the water? Tellers of tales like to think so.

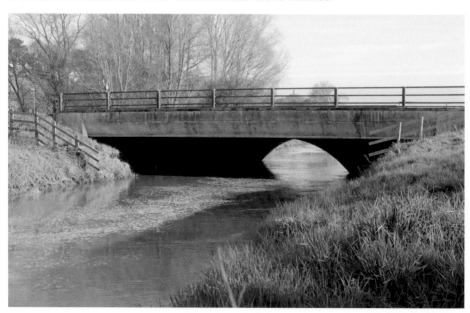

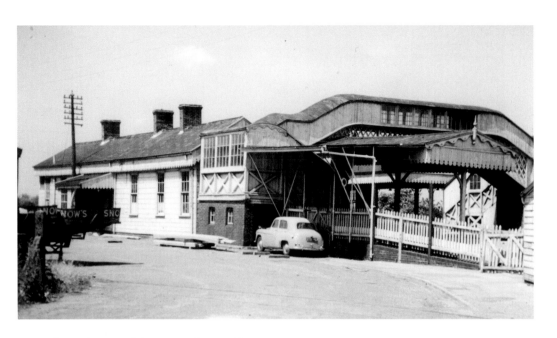

Glastonbury and Street Station, 1966

Glastonbury and Street station looks so normal in this 1966 picture. A John Snow's timber yard vehicle has parked just outside, a white car is under a rough awning, and the small wooden gate is ajar onto the platform. But the final train had actually passed through some months ago, and the familiar appearance was already an illusion. Soon, all was destroyed, though a replica level crossing gate leads into the site where various activities now do business. Unsurprisingly, the line from Highbridge came from the need of the Clarks for the latest and fastest outlet for their boots and shoes onto the national market. Though the name of Glastonbury came first, the 'and Street' wording said just that: it was Street's station too, not only for freight but for passengers. Up to the year of closure, Street people would still walk to catch a train, all the way over the Causeway, into the New Road (never really used, and now closed off) and into the station. We rarely used the proper booking office entrance, but slipped through the little side gate onto the platform first.

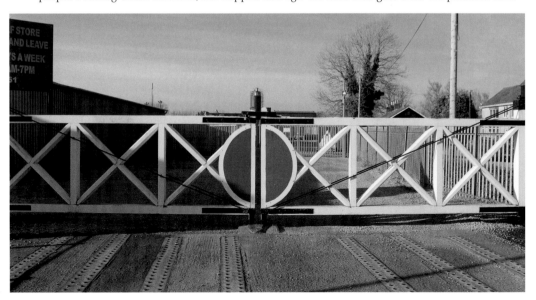

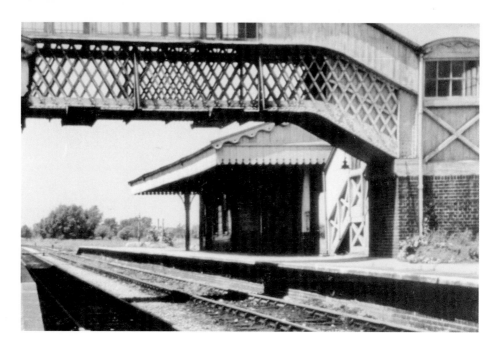

Glastonbury and Street Station, 1966 Continued

Although little sign of the station now exists, a few mementoes have been saved and taken elsewhere; here a clock, there a signal in someone's garden, plus the platform canopy which was re-erected in the car park just behind St John's church at Glastonbury, forming useful shady parking. Facetiously, we debate whether to park on Platform 2 or 3. Beyond that, the remains of the Glastonbury and Street destination sign is here seen reduced to concrete stumps, but with a pink rose still struggling up it. Railwaymen took great pride in maintaining platforms between arriving trains. In wartime the Central Somerset became a useful route for military freight, bypassing the dangerous cities to reach the Channel ports. But there was still time for the crew of the tiny Wells branch train, starting from its own bay behind the canopy, to fry eggs by holding a shovel inside the flaming firebox, in between jobs like loading crates of live hens or boxes of Clarks shoes into the guard's van.

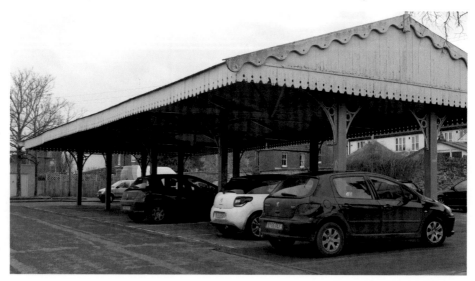

Acknowledgements

Firstly, special thanks to Neil Clarke who took all the 'as now' photographs in mid-winter; and to Margaret Crockett for loaning a number of pictures from the 1960s/70s. Also to Nina Swift and The Street Society for support through this project. Thanks also go to: Alfred Gillett Trust, *Central Somerset Gazette*, Tim Crumplin/Clarks Archives, Ken Dunthorn, Glastonbury Fire Brigade, Mary Hecks, Colleen Hinde, Mary Hughes, Joan Middleton, Colin Mundy, Jim Payne, The Salvation Army, Sheila Savage, and Street United Reformed Church. Identifiable publishers of historic picture postcards include Hellikers, F. Higdon, K Series, MJR, RA Series. Otherwise most of the pictures come from the author's collection and from family albums. Over the years many have been donated but without any record of their original publishers. To those who are thus now untraceable, sincere thanks are offered. And, finally, thanks to my husband, Revd Martin Mudie, for being my chauffeur, 'gofer' and general helper.

West End Bakers, 1960s.